MIDLOTHIAN
PUBLIC LIBRARY

IMAGES
of America

FLOSSMOOR
ILLINOIS

IMAGES
of America

FLOSSMOOR
ILLINOIS

Elise D. Kabbes
and Mary GiaQuinta

ARCADIA

Published by Arcadia Publishing,
an imprint of Tempus Publishing, Inc.
2 Cumberland Street
Charleston, SC 29401

Printed in Great Britain.

Library of Congress Catalog Card Number: Applied for.

For all general information contact Arcadia Publishing at:
Telephone 843-853-2070
Fax 843-853-0044
E-Mail arcadia@charleston.net

For customer service and orders:
Toll-Free 1-888-313-BOOK

Visit us on the internet at http://www.arcadiaimages.com

CONTENTS

ACKNOWLEDGMENTS

The authors would like to thank Dee Canfield and the staff of the Flossmoor Public Library, with very special mention to Chris Schmitt, who volunteered so many hours and kept us organized. We would also like to recognize the support of the Village of Flossmoor, including Mayor Roger Molski, the board of trustees, village manager Peggy Glassford, Dariel DeWit, Tom Fleming, the chairman of the 75th anniversary committee, and vice chair Karen Hoag. We also appreciate the contributions of Abby Sheehan and Pat Paulsen.

The book would not have become a reality without the many historic photographs donated by past and present residents, some of whom are Richard Condon, Winifred Vanderwalker Farbman, Dora Nietfeldt, Geri Nelson Aron, Michael and Patty Krokidas, Fred Zum Mallen, Edwin Salter, Jane Peddicord, and Steven and Anna Soltes. The authors also appreciate the cooperation of the many institutions that opened up their files to us: the Flossmoor Fire Department, the Flossmoor Community Church, and Infant Jesus of Prague Catholic Church, among others.

The authors are very grateful to the present and former members of our village who sent us their personal reminiscences of growing up in Flossmoor—Richard Condon, Geri Nelson Aron, Laura Catherine Adams Vanderwalker, Arnold Woodrich, and Spencer Irons. The books *Indian Trails to Tollways* by Anna B. Adair and Adele Sandberg, and *Flossmoor: Then . . . Now*, as well as *The History of School District 161, 1860–1928*, by Bonnie J. Swatek, were helpful background materials.

The personal histories and historic photographs donated for this project will hereafter be kept in the village archives at the public library, so that anyone may enjoy our history and understand what life was like over the years. The authors acknowledge, however, that some aspects of Flossmoor's history may not be included in this book. We tried by many different means to reach out to the community to get photographs and histories, but, regrettably, some may have been missed. Anyone may still bring material to the Flossmoor Public Library for inclusion in the archives that will be maintained there.

INTRODUCTION

Seventy-five years ago, in June of 1924, residents voted to incorporate the Village of Flossmoor, Illinois, by a vote of either 78 in favor, 60 against, or 68 to 60, depending on various accounts. The vote was the result of a movement that began in the furnace room of the new Leavitt Avenue school, where the men gathered for a "smoke" during a PTA dinner. At the time of incorporation, the population of Flossmoor was 265, and the village encompassed almost two square miles.

The settlement of Flossmoor leading up to incorporation was the outgrowth of three distinct movements. German immigrants fleeing political upheaval in the 1840s were the first European settlers in the area, attracted by the rich, dark soil and rolling hills. Hecht, Doepp, Vollmer, Nietfeldt, Stelter and Vanderwalker—these are some of the first families of Flossmoor, many of whom still grace the community.

The commercial ventures of the Illinois Central Railroad are the second significant factor in the development of Flossmoor. According to several histories of the area, the Illinois Central purchased 160 acres of land north of Flossmoor Road, and west of Western Avenue, in 1891. The land was to provide fill-dirt for I.C. projects in Chicago, until the I.C. determined the dirt unsuitable. In a classic free-enterprise move, the railroad extended train service to Flossmoor, subdivided the land, built six houses, and put them up for sale.

The Flossmoor train depot was, and is, the hub of Flossmoor. The first station, on the east side of the tracks, was not meant for passengers, and early visitors walked across planks laid over the tracks to disembark the train. Arnold Woodrich recalls that station agents also acted as postmaster, overseeing a stack of cubbyholes. When requesting mail from Mr. Fagin, Mr. Woodrich remembers "us nasty small fry [would] insert the small piece of cardboard containing the name of a candy bar of the time, Nutty Fagin." By 1912, the station had been rebuilt on the west side of the tracks and an underpass had been constructed for passengers. Electrification of the train in the mid-1920s transformed Flossmoor into the suburban commuter stop we know today.

The extension of the train line and the settlement of Flossmoor had one final impetus—golf! *Ye Olde Towne Crier*, published by Flossmoor State Bank, November 2, 1929, printed a "Statement of Mr. John F. Gilchrist to Mr. Thomas G. Grier" that is an "illuminating story, which, unless it is successfully refuted, will be considered the authentic story of the beginning of Flossmoor." According to Mr. Gilchrist's account, on July 8, 1899, he and Fred Jenkins, both employed by the Edison Company and living in Hyde Park on the south side of Chicago, were

having lunch at the Chicago Athletic Association when they decided there should be a golf club somewhere on the Illinois Central line.

By April of 1900, Messrs. Jenkins and Gilchrist had purchased property in Flossmoor from August Hecht and Chris Hibbing, two German farmers, for $125 per acre. These ambitious fellows also received assurances from representatives of the Illinois Central that they would extend their train service from Homewood and build a depot. This year, the Flossmoor Country Club celebrates its hundredth anniversary, still nestled in the original neighborhoods of Flossmoor with street names bearing witness to the founders' love of golf—Evans, Caddy, Bunker, Brassie, and Hagen.

Since its incorporation, the needs of the community led to a charming downtown, lovely churches, stately homes in neighborhoods dotted with flowering trees, and expansive golf courses and parks. Along with its historic train station, the Tudor-style Civic Center in downtown Flossmoor gives the village its signature look. From 1930 to 1950, the Civic Center, with its cross-timbers and ornamental shields, housed the village hall, police and fire departments, stores and apartments, and still serves as the town's centerpiece.

The name "Flossmoor" came from a competition held by the U.S. Postal Service. Flossmoor is Scottish in origin, meaning "dew on the flowers" and "gently rolling hills." Street names were chosen to reflect this Scottish theme, such as Braeburn, Argyle, and Wallace. Many of the first homes, other than the German farmsteads, were originally built as summer homes by Illinois Central executives, and the University of Chicago faculty.

Spencer Irons recalls, "By 1921, he [his father, a Chicago physician] felt the need to find a place where he could relax from the tensions of day-to-day dealing with patients and students and their medical and emotional problems." These weekend residents built the grandest of "cottages," many in the style of the Prairie School of architecture popular in the 1920s and '30s. Flossmoor is home to a Frank Lloyd Wright "Fireproof House."

The events that gave impetus to the development of Flossmoor still define its community today—the rolling, fertile land that drew the first German settlers, the Flossmoor train station where commuters shuttle to and from Chicago, the grand old neighborhoods filled with "summer cottages"; and, of course, the golf courses. These are the things that define Flossmoor.

One

THE TRAIN STATION

The Illinois Central Railroad (I.C.) played one of the largest roles in the growth of Flossmoor. On February 2, 1891, the I.C. bought 160 acres north of Illinois Street (later renamed Flossmoor Road), and west of the tracks, to be used as fill-dirt. The original station was on the east side of the tracks, and used only for commercial purposes.

By 1910, the Illinois Central had determined the dirt was unsuitable as fill, so they tried to interest people in settling here. They ran special trains from Chicago offering free lunch to interested buyers, and operated "Golf Specials" on Saturday and Sunday mornings. In his personal history of summers in Flossmoor, Spencer Irons explains that the first trains were "small, wooden coaches and small steam locomotives which had been put into service to transport passengers to the World's Colombian Exposition in 1893."

According to Mr. Irons, the original exit was via a brick platform to the north. "The exit to Flossmoor Road at the south was opened when the raised wooden platform was installed in about 1925," Mr. Irons writes. Many of the histories of Flossmoor point to the electrification of the trains between 1919 and 1926 as pivotal in making Flossmoor the popular suburban community it is today.

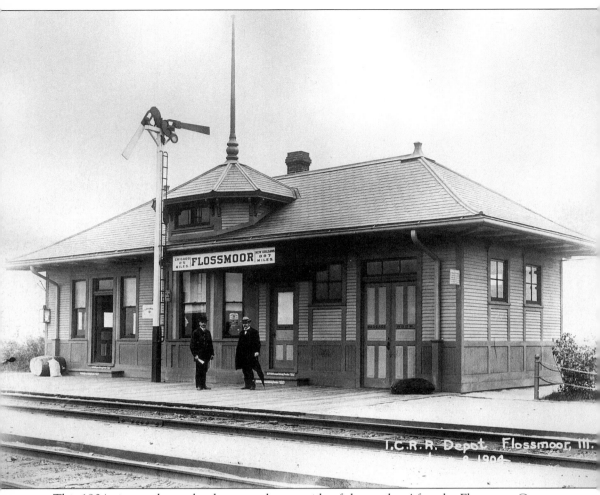

This 1904 picture shows the depot on the east side of the tracks. After the Flossmoor Country Club opened, and before the station had been fully converted to a passenger facility on the west side of the tracks, the railroad would lay planks across the rails for people exiting the train.

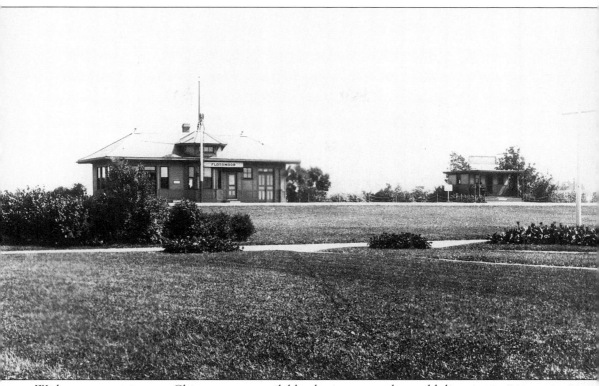

With transportation to Chicago now available, business people could live in a country atmosphere and work in the city. Flossmoor resident Spencer Irons remembers that before they had an automobile, "my father walked the mile or so to the I.C. station in the morning (12 1/2 minutes) and from the station in the evening (12 1/2 minutes). He could tell us how many paces it took."

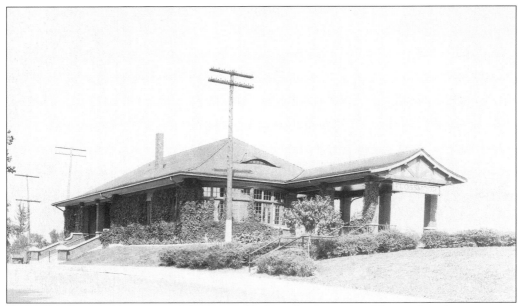

Shown here is an early picture of the station built on the west side of the tracks, where it stands today. Easy access to Chicago has always been an attraction of Flossmoor. Geri Nelson Aron writes about trips to Chicago on the train with her mother: "In the beginning, our train was pulled by a big black engine. Noisy and steam-belching it would gradually pull us away from the station on our way to our great adventure of the day."

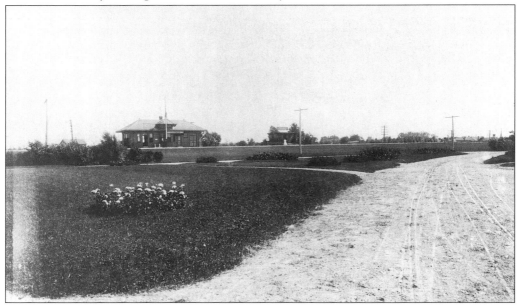

In his personal history, *The Early Years*, Flossmoor resident Spencer Irons recalls that "a number of Flossmoor residents were I.C. employees, including Daniel J. Brumley, one of the railroad's top engineers. Another group of residents were University of Chicago professors, including Dr. Jordan and Gilbert A. Bliss, the chairman of the Department of Mathematics." D.J. Brumley served as the first village president from 1924 to 1927.

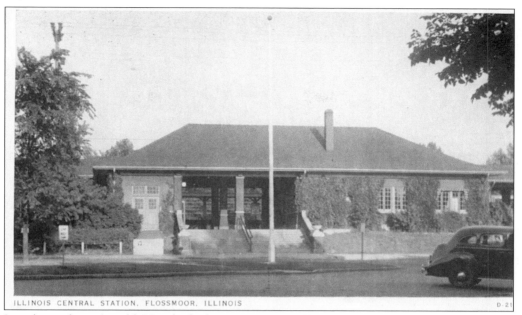

ILLINOIS CENTRAL STATION, FLOSSMOOR, ILLINOIS D-21

In a letter from Arnold Woodrich, he says "as I recall it at first, the station had no other function than to provide a waiting room and an enclosure for the station agents, who, as a sideline to their ticket selling-function, also acted as postmaster. The postal installation consisted of a stack of cubby-holes. Delivery was achieved by asking Mr. Fagin (known to the 'small fry' as 'Nutty Fagin,' a popular candy bar) . . . for the contents of one's box."

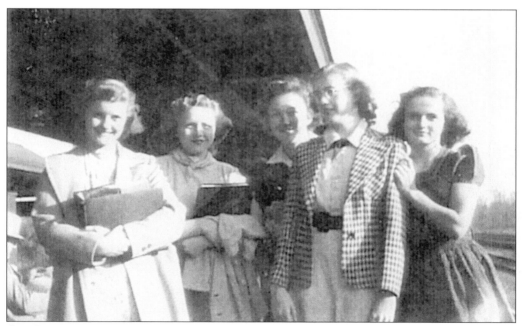

Ann Perry, Mary Ann Gavin, Jean Carrier, Jane Perry, and Ginny Marshall wait for a train on the Flossmoor station platform in 1938. Easy access to Chicago by train still makes Flossmoor one of the most attractive suburbs in the area.

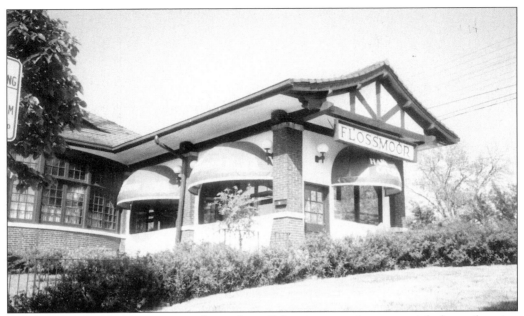

For many years, the train station housed small boutiques and commercial shops, keeping downtown Flossmoor a vibrant, village center.

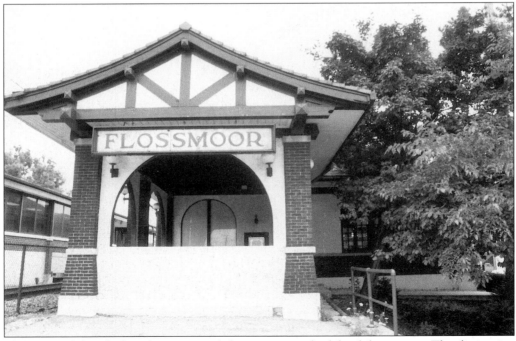

This view of the platform has remained the same over the life of the station. The distinctive roof-line and lettering would be recognizable to any past or present resident.

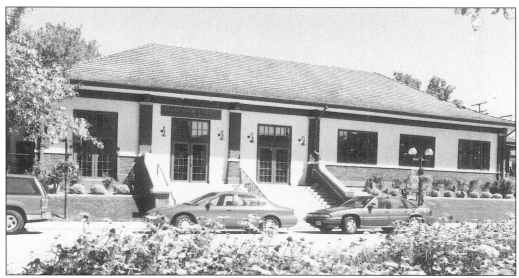

Today, the station has been converted into a micro-brewery and restaurant. The owners restored many of the decorative features of the original building, such as the mosaic tile work, and have added a wonderful collection of historic train photographs.

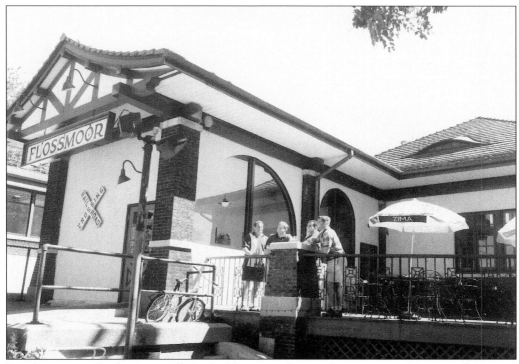

Residents can ride, skate, or walk to the Flossmoor Station Restaurant and Brewery for micro-brews or root beer floats. The miniature train that runs the length of the barroom ceiling, and the rumble of the real trains passing by make the Station a favorite gathering place for residents of all ages.

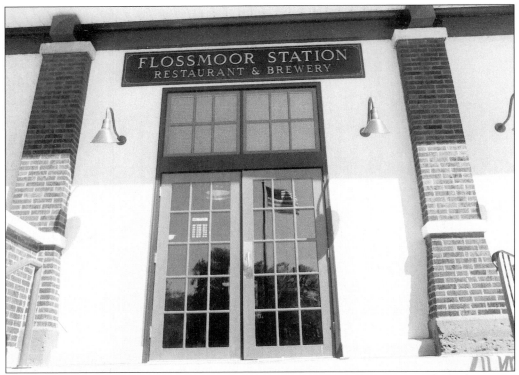

Today, the distinctive atmosphere, fine food, and micro-brews draw visitors from the entire region.

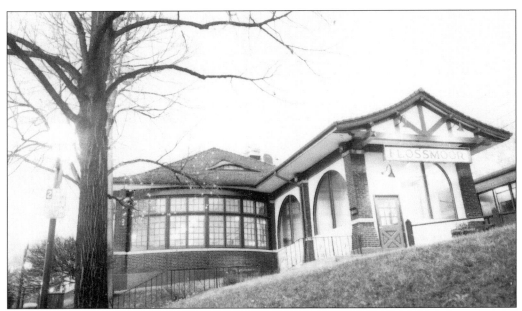

Despite many changes, the architecture of the original station endures.

Two

PUBLIC BUILDINGS

The needs of the village government created much of the architecture in Flossmoor. In 1929, the cornerstone was laid for a new Civic Center, a block-long, Tudor-style structure that still gives Flossmoor its small-town appeal. The Civic Center was built to house the village hall, fire and police departments, the public library, several large stores, and modern apartments.

The Depression gave the Civic Center a difficult start. The Flossmoor State Bank was in business only five and a half years, from 1928 to 1934, although depositors were paid one hundred cents on the dollar when the bank closed its doors. Many stores remained vacant in the 1930s. During its history, the Civic Center has been home to the Flossmoor Super Mart, Schlatt's Hardware, Lapin Pharmacy, Flossmoor Bakery, and many other local businesses.

As chronicled in a history of the Civic Center by Dick Condon, who grew up there, the building has many "bas-relief carved stone motifs imbedded into the brick facing." According to Mr. Condon, the symbols on this grand old building represent the Lions Club, Kiwanis Club, Exchange Club, and the University of Chicago, along with carved eagles, lions, apothecary mortar and pestle, heraldic shields and golfing images.

In 1950, the village built a new village hall, a lovely colonial-style structure, on the north side of the downtown traffic circle. When the village government moved to a new building on Flossmoor Road in July of 1979, the public library took over this attractive building.

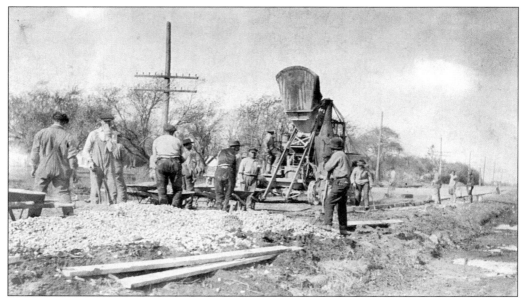

The building of Dixie Highway through Flossmoor opened up a major north-south artery that played a large part in developing the area. Dixie Highway was constructed over what was known as the Vincennes Trail. Some of the first land purchases by German immigrants were along Dixie Highway on the east side of Flossmoor, and the original Hecht home still stands on the highway.

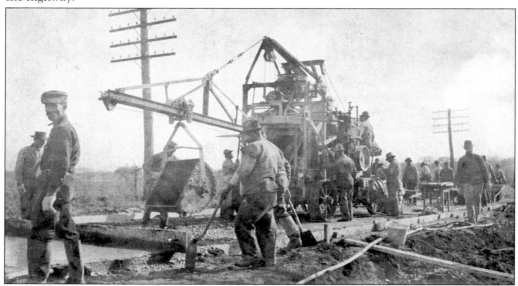

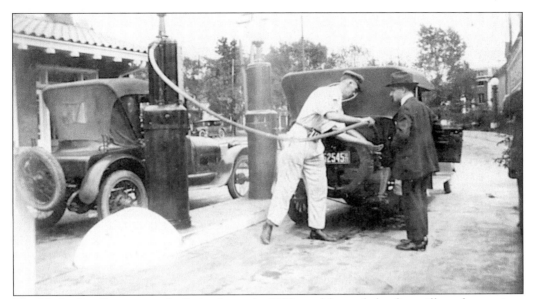

The Hyde Gas Station was built in the early 1920s and housed the first village fire engines before the Civic Center was finished. The family of teenage attendant Bert Hecht later owned the Hecht Grocery Store from 1928 to 1945. The store was located next to the Civic Center on Sterling Avenue.

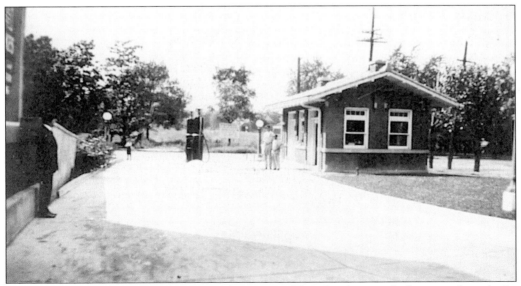

In the early years, the gas pumps were in the center of Douglas Avenue, before a road was built. Mr. Hyde was also well known by Flossmoor's children as the school bus driver.

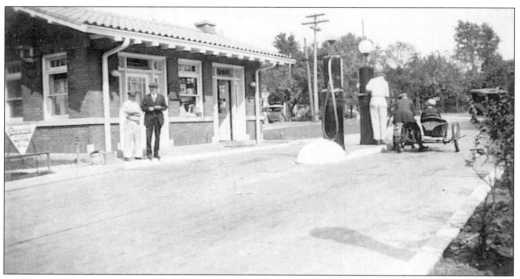

Although it has gone through many remodeling changes, the Flossmoor Gas Station is still a fixture in town.

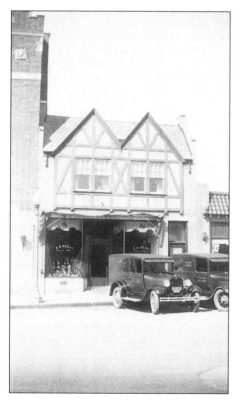

Albert Hecht, offspring of one of the founding families of German settlers, built this grocery store in 1928 on Sterling Avenue, and operated the store until 1945. For several years during the Depression, the Hecht grocery was one of the few stores in Flossmoor.

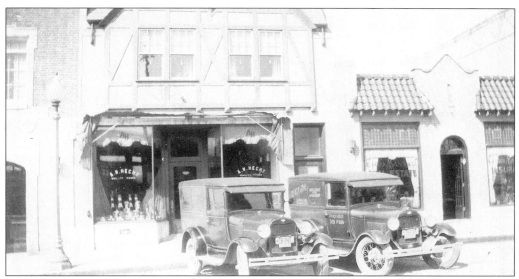

Many old-time residents of Flossmoor remember receiving deliveries of groceries and meats from A.W. Hecht in the early years. Geri Nelson Aron remembers the Hecht's generosity during the Depression: "Mr. and Mrs. Hecht who owned a little grocery store on Sterling Drive were extremely kind and gave my mother credit for the necessities which she would pay for as she could in small amounts."

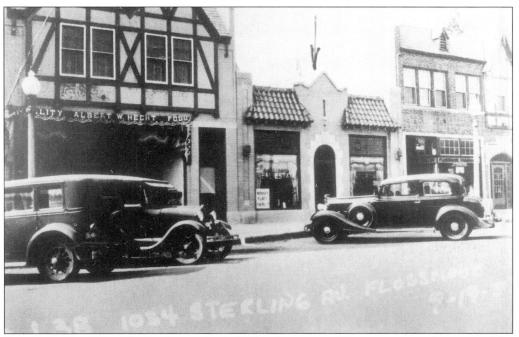

Geri Aron remembers the Hechts of the A.W. Hecht grocery: "He was a giant of a man and she was a very little woman. In about the middle of the store was a . . . booth . . . where you paid for your groceries. Mrs. Hecht was always in that booth—I don't ever remember seeing her out of it!"

This 1937 picture was photographed by Edwin Salter, whose teenage hobby was photography.

Edwin Salter recalls being given a new camera as a teenager, and as cars were a favorite subject of his, he walked around town taking these pictures. He maintains a large collection of photographs of cars from the 1930s. In the background is a rare photograph of Leavitt Avenue school, which replaced the two original, one-room schoolhouses in the area.

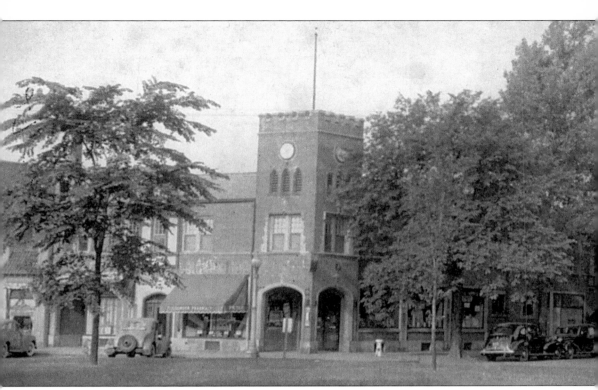

The northeast corner of the Civic Center originally housed the Flossmoor State Bank, which closed in 1934, after five and a half years in business. In September 1931, in the middle of a working day, the bank was robbed by three men. They escaped with $2,811.41 but were caught later in Indiana.

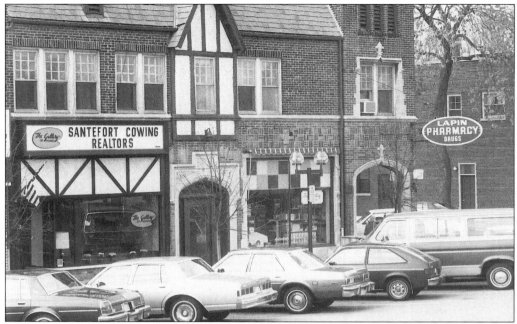

For many years, the drugstore occupied the corner space of the Civic Center. In the early years, when residents wanted to call the police, they would notify the pharmacist, who would put a sign up in his window for the officer on duty. Residents who grew up in Flossmoor also remember the pharmacy for its wonderful ice cream sodas.

This entrance to the Civic Center leads to the second-floor apartments, where many families raised their children during the Depression. They played "kick the can" and "alley ball" in the back courtyard and fixed up old cars in the garage, according to Dick Condon.

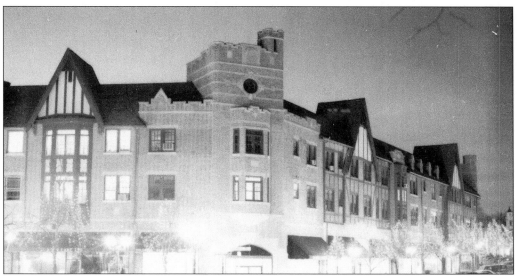

Today, during the winter months, downtown Flossmoor is lit by hundreds of strands of white lights that create a magical charm of times gone by, amidst a modern suburban community.

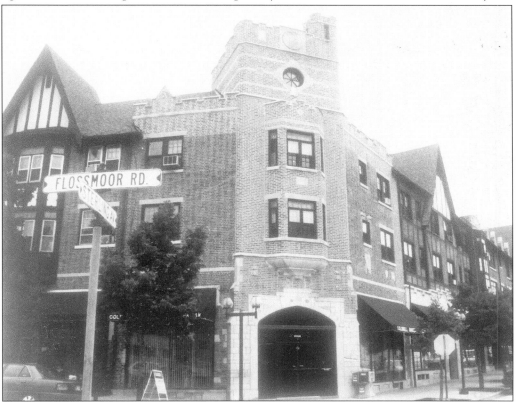

The southeast corner of the Civic Center displays the signature traits of the building, including peaked roofs over gabled and stucco siding, notched facades, and decorative carved stone motifs.

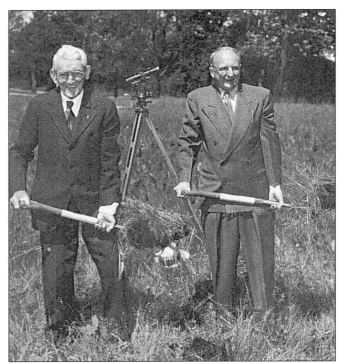

In 1950, the village broke ground for a new village hall, located on the north side of the downtown traffic circle. D.J. Brumley, the first village president and one of the top engineers for the Illinois Central Railroad, scooped the first shovels of dirt, along with Lawrence Myers, the village president at that time.

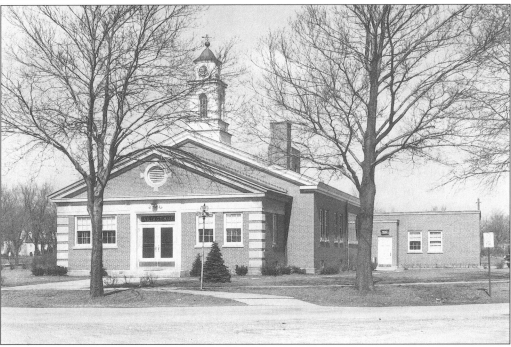

This New England-style colonial building, located on the north side of the downtown traffic circle, housed the village hall, and the police and fire departments, from 1950 to the late 1970s. Today, the building is used by the Flossmoor Public Library.

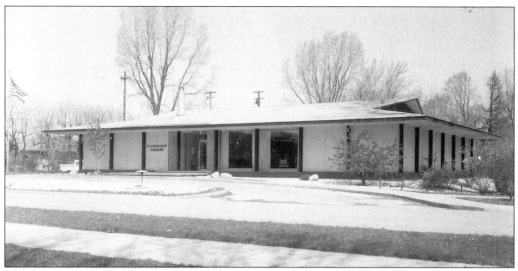

In 1961 the library built a new building at School and Douglas Streets, which cost $145,000. From 1954 to 1961, the library was housed in a rented storefront in the Civic Center. Originally, the library was staffed by volunteers from their homes. Today this building houses the Reorganized Church of Jesus Christ Latter Day Saints.

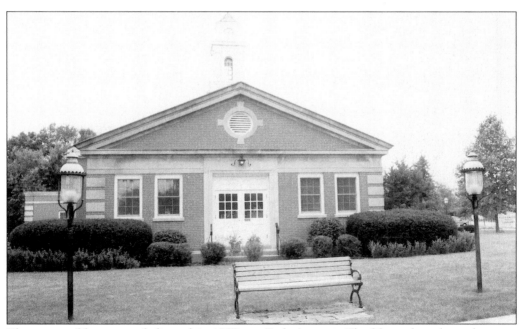

The present library was dedicated in 1983, on Park Avenue. The library has always been an inviting place in downtown Flossmoor, widely used by residents of all ages, and now boasts a charming bronze statue of two children sitting on a park bench reading *The Secret Garden*.

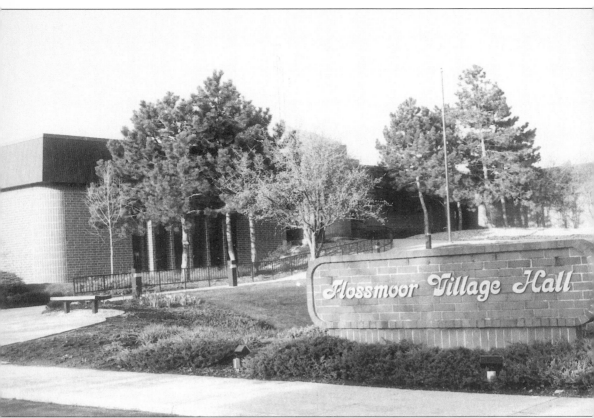

This modern facility, which houses the village hall and the police and fire departments, was completed in July of 1979. Flossmoor has always prided itself on a government that is professionally administrated, and today has a village manager, assistant village manager, and full administrative staff. Village residents elect a mayor and six trustees who serve four-year terms.

Three

FIRE AND POLICE DEPARTMENTS

Four years after the incorporation of Flossmoor, the volunteer fire department responded to its first call in December 1928. After public moneys were used to purchase the first American La France engine, public moneys were not used again until 1965. During those many years, the department was funded by private donations and proceeds from the annual Firemens Ball. The Flossmoor Fire Department is still manned mainly by volunteers, although they are not called into service by a siren as they were before the mid-1970s.

For many years, the Flossmoor Police Department reflected the small-town environment it served. The first police magistrate was paid just $1 per year, and at first used his own car for patrol. Residents on Brassie Avenue and Braeburn Street hired their own night watchman to patrol the neighborhood with his two dogs.

According to the history *Flossmoor: Then . . . Now*, until 1935 "residents wishing to make complaints had to make them to the officers while on their patrol." After telephone service was in place, the operator could turn on a red light on top of the water tower, if she felt the call required police action. If there was no answer at the station, the local drugstore in the Civic Center would take the complaint and post a card in the front door of his store so the officer would stop.

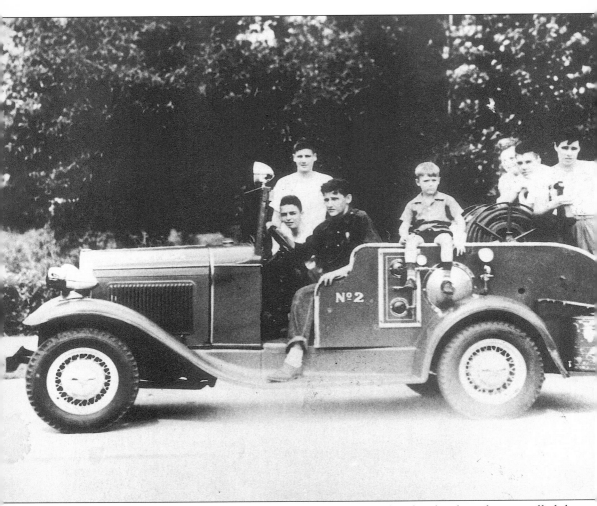

This American La France Foamite engine used a very short-lived technology that propelled the water with a soda-acid chemical mixture, instead of a motorized pump. The engine was essentially a big, old-fashioned fire extinguisher on wheels. The first Flossmoor engines were under the command of Chief John S. Smith and Assistant Chief George Busse, and manned by 16 volunteers.

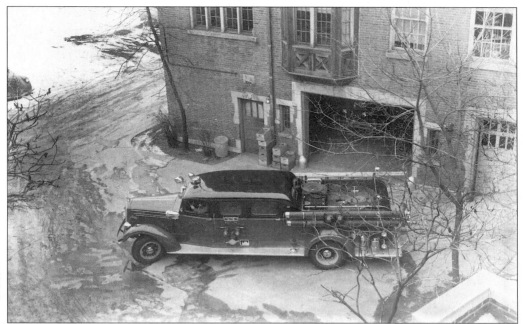

In 1929, the fire department moved into quarters in the rear of the Civic Center, where it stayed until 1950 when it moved to the village hall on the north side of the circle. Maneuvering the engine out of the garage in the back of the Civic Center was no easy task, requiring a three-point turn into a narrow alley.

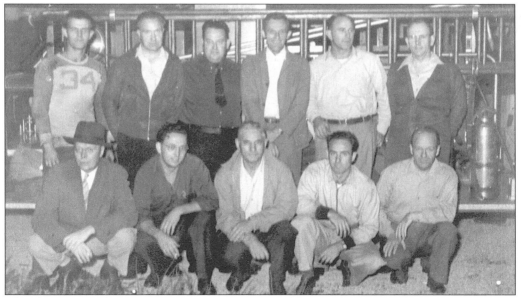

The Flossmoor Volunteer Fire Department is pictured here in 1945. From left to right are (front row) John Blair, fireman; C.H. Sullivan, fireman; Thomas Logan, former Chicago Battalion Chief; Ed Kelly, fireman; and Harry Jordan, fireman; (back row) Brenton Hoover, fireman; W. Waldal, fireman; Richard Foster, acting chief; Joe Shimkus, assistant chief; Chuck Palmer, fireman; and Thorpe Wright, commissioner.

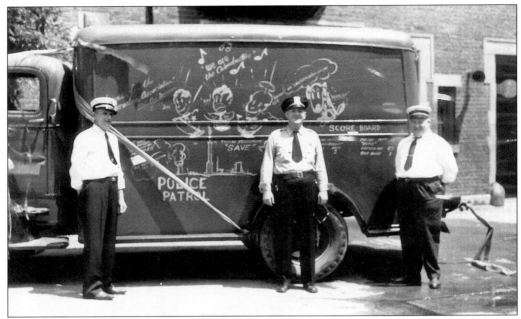

Public servants from the Flossmoor Fire and Police Departments pose in front of a paddy wagon that has been decorated for a community event.

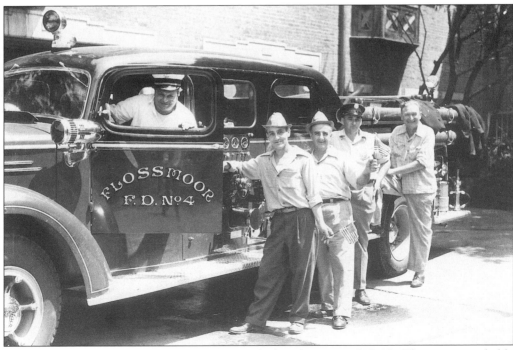

This is the Flossmoor F.D. No. 4 Engine with five firemen, 1947-48. They were probably preparing for the Annual Fourth of July parade, sponsored by the fire department for many years.

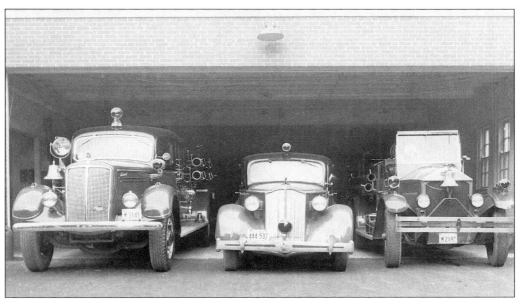

These three fire engines from left to right are a 1947 Mac Pumper; a Packard Ambulance; and the 1929 America La France engine, pictured in the "new" village hall in 1951. The triple-wide garage must have been quite a luxury for the volunteers who had previously been in cramped quarters in the back of the Civic Center.

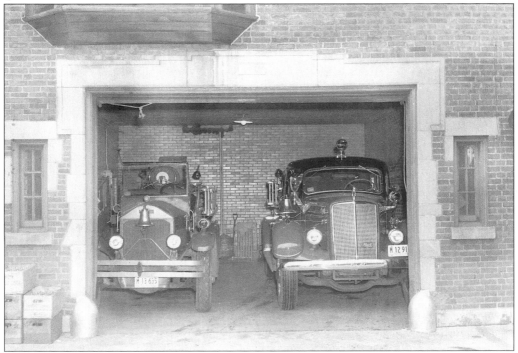

This is one of the last photographs of engines housed in the back of the Civic Center before the fire department moved to new quarters in 1950. Often, one engine had to be moved out into the alley before the second truck could be sent on its call.

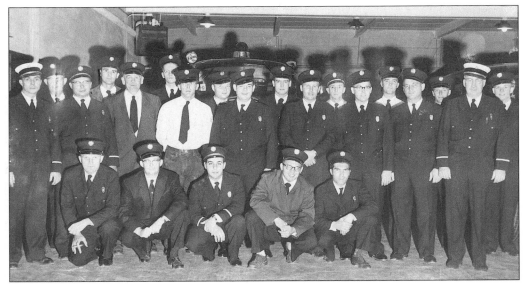

This 1951 photograph of the volunteer fire department includes two future fire chiefs that would serve the community for many years: Jack Brooks, far left, and Peter Vandercook, in the middle, standing with his eyes shut.

Socializing has always been a way for firefighters to gain trust in their co-workers. Here, former Chiefs Vandercook and Brooks (center) enjoy a group shot at the Firemens Ball. For most of its history, the annual Firemens Ball was held at the Flossmoor Country Club, and, for many years, proceeds from the Ball were the department's only revenue.

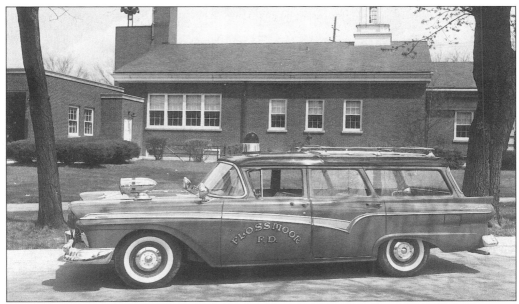

The fire department put this sleek station wagon into service in the mid-1950s. The siren, which called volunteers to service, is visible on the top left of the village hall.

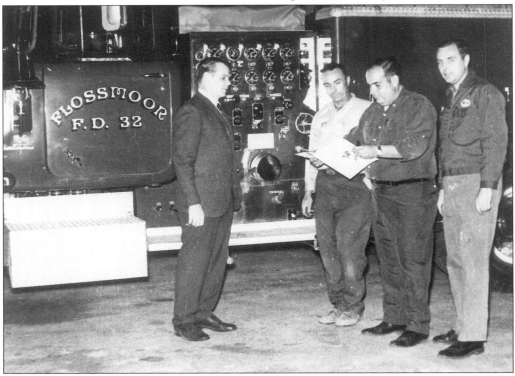

Fire Chief Peter Vandercook took delivery of this Engine No. 32 Mac Truck in 1970. Retired chief Jack Brooks stands on his right. During Vandercook's tenure as chief, the volunteers would judge the severity of the fire by the number of cigars the chief chewed.

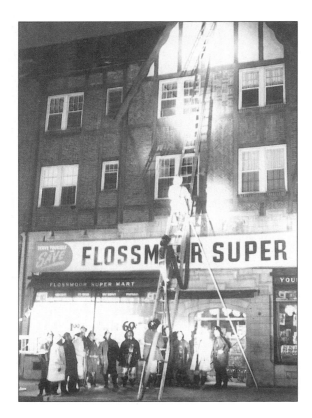

Firefighters respond to a call in the apartments above the Flossmoor Super Mart in the Civic Center.

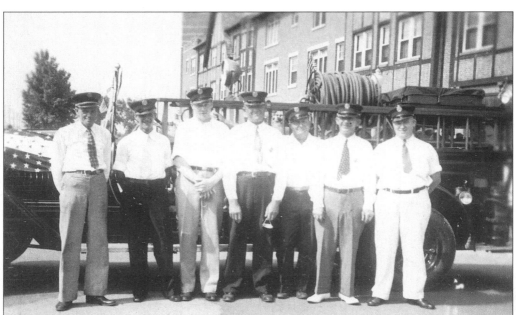

The 1950 fire department included Norm Kantzler, Fred Wollenberg, Henry Dickman, Harry Sundeen, and Dick Foster, among others.

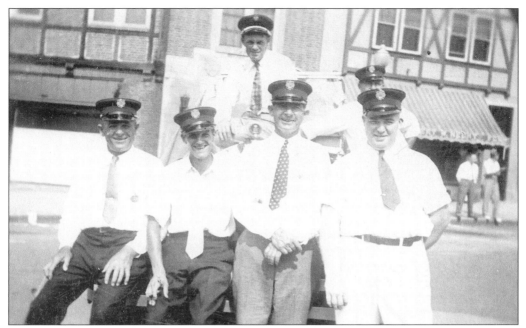

The fire department volunteers are pictured here in the 1950s. From left to right, in the front are Fred Wollenberg, Harvey Hyde, Harry Sundeen and Dick Foster. In the rear are Norm Kantzler and Henry Dickman.

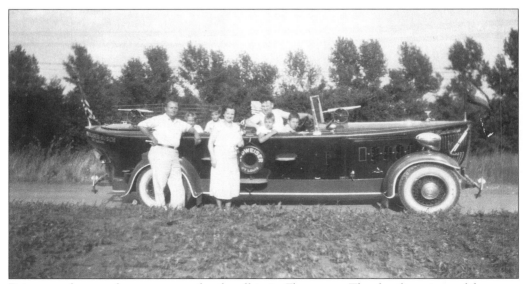

Being a volunteer fireman was a family affair in Flossmoor. The families pictured here are (driver) Dick Foster with Bud and Dickie Foster, Pat and Bud Dickman in the back seat, and Henry and Marg Dickman standing.

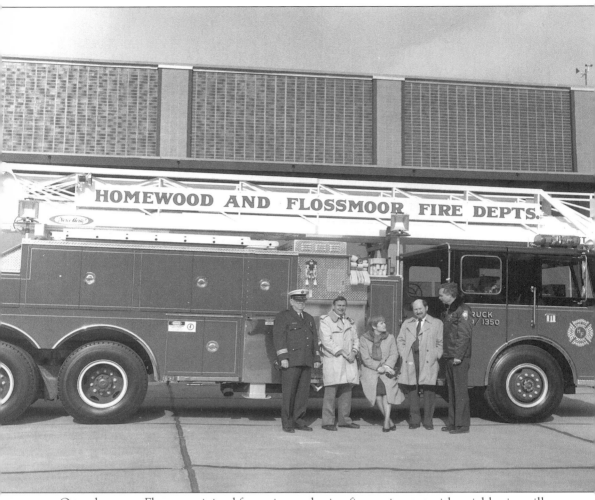

Over the years, Flossmoor joined forces in purchasing fire equipment with neighboring villages. Pictured here are Joe Klauk, Homewood fire chief; Manny Hoffman, Homewood mayor; Peggy Glassford, Flossmoor village manager; Larry Lowery, Homewood village manager; and Greg Berk, Flossmoor fire chief.

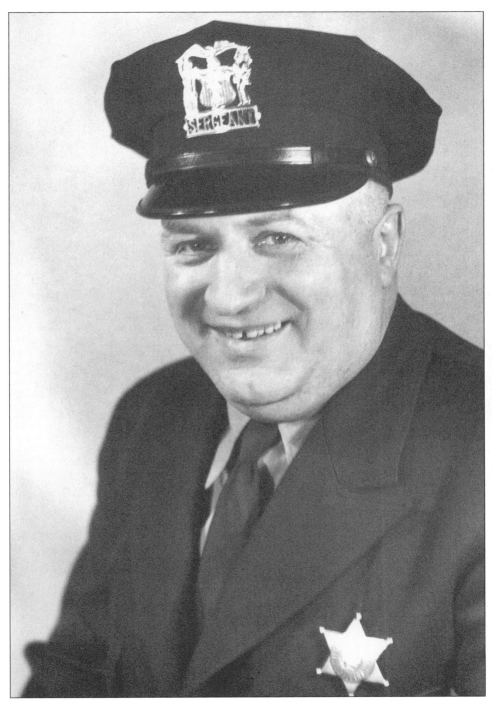

Clifford Pauling, a popular police chief known as "Opie," first joined the Flossmoor police as a patrolman in 1935. He was promoted to sergeant in 1943, became superintendent of Public Works in 1950, returned to the police department as lieutenant in 1953, and was appointed chief of police in 1956 due to the death of Chief Joseph Dineen.

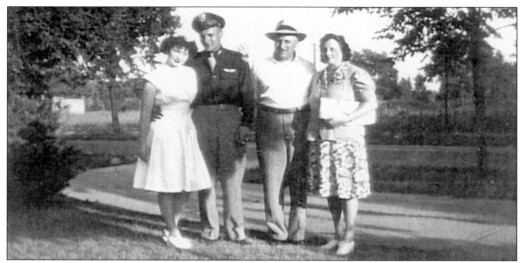

This 1944 photograph pictures Opie and Verna Pauling with their son Opie Jr. and his wife Geri, nee Nelson. After coming home for a short leave, "Little Opie" returned to Kingman Arizona where he was being trained in the flying of the big B-17 bombers or "flying fortresses" as they were called. Shortly after, Geri took the Atcheson, Topeka and the Santa Fe R.R. to Kingman where they were married.

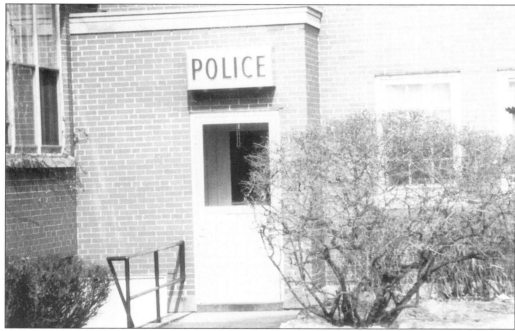

After being housed in the Civic Center for 20 years, the police department moved to the new village hall in 1950, into what is now the public library. The jail was right next to the police chief's desk. Due to the small size of the department and the commitment of those who served, the police department was manned by very few men over the years. Joseph Dineen was chief of police from 1934 to 1956, and Clifford "Opie" Pauling was chief from 1956 to 1969, after starting as an officer in 1935.

Four

SCHOOLS

The current School District 161 was formed in 1928 when two one-room schools, one on Kedzie Avenue on the west side of Flossmoor, and one on Dixie Highway on the east, were joined into one district. As recorded in a history of District 161 by Bonnie J. Swatek, the school on Dixie Highway (then known as Vincennes Trail) was first built on a grant of land from Benjamin Butterfield. The name of the school was later changed to the Stelter School, since it was across the road from Henry Stelter's farm.

The modern era was ushered in with the building of Leavitt Avenue school in 1922. Leavitt Avenue school was quite fancy in its day, with two rooms, a basement, plumbing, a furnace, and electricity. By the late 1920s, the schools were experiencing such overcrowding that overflow classes were housed at the community house in Flossmoor Park. Eventually, a second story was built onto the school, and it served the community until it was razed in 1987.

As with so many institutions in Flossmoor, its high school grew out of community activism. Prior to the 1950s, teenagers on the east side of the I.C. tracks went to Bloom High School and those on the west side went to Thornton High. After its first effort to petition for its own school district was deemed to have inadequate eligible signatures, the community rallied and tried again. Finally, in 1956, the Cook County School Board accepted a petition signed by 8,060 residents in Flossmoor, and neighboring Homewood, to create Homewood-Flossmoor High School. The high school is still an architectural phenomenon today, and a center of community life.

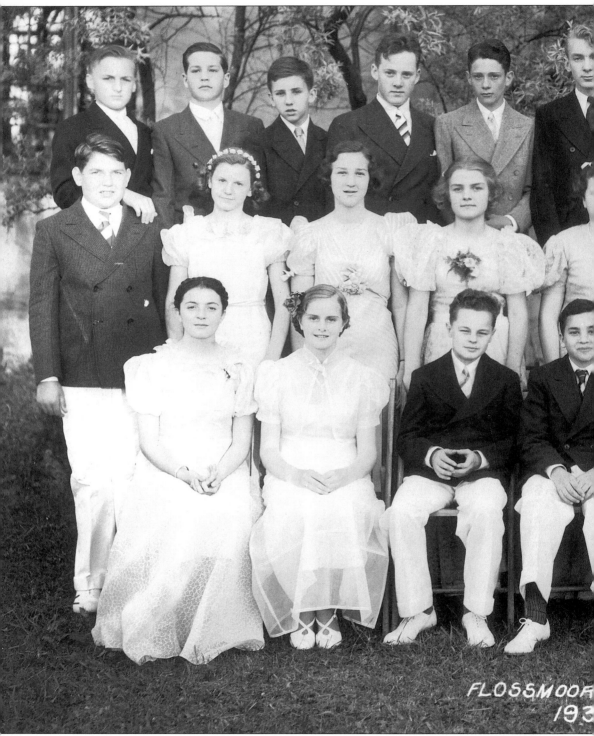

FLOSSMOOR
193

In this photograph of June 11, 1937, is the Flossmoor School graduation class. A graduation

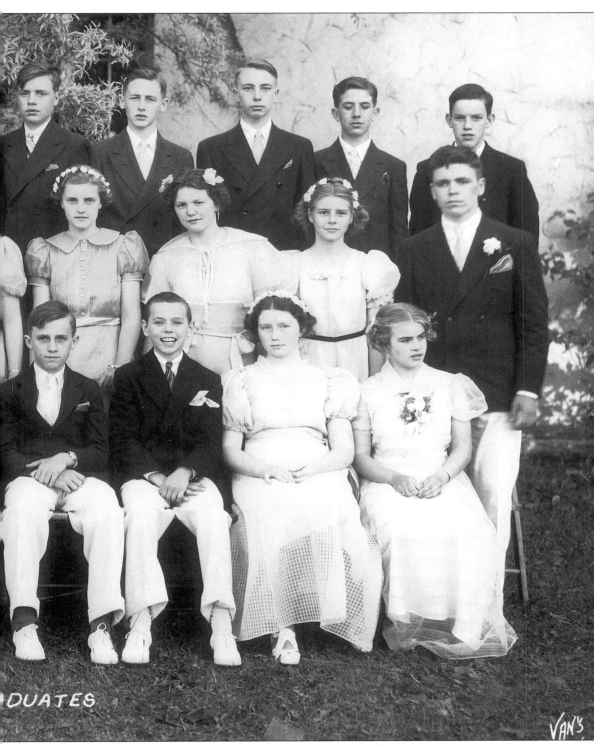

DUATES

party was held after the ceremony at the Flossmoor Community House.

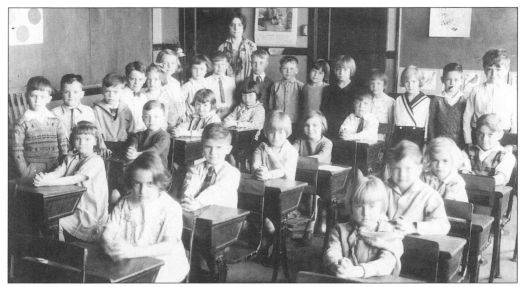

Pictured here is the 1929-1930 Flossmoor School first grade class.

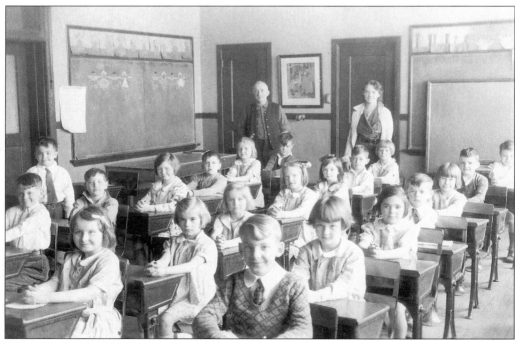

This is the 1930-1931 Flossmoor School second grade class.

44

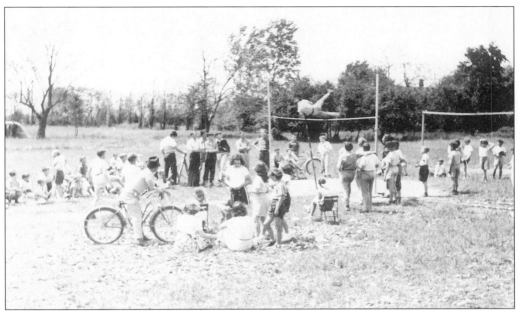

This is the Flossmoor School field day of June 1938. The elementary schools in Flossmoor School District 161 still hold a field day each June. The day consists of track and field competitions for students of all ages. Pole-vaulting in sand pits is probably no longer included, given the liability concerns in today's society.

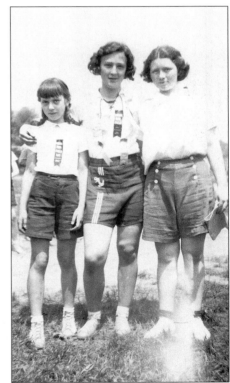

This picture from May 1937 is of a field day at Flossmoor School. Two of these girls apparently had some success in the field day competition. From left to right are, "Bobby" Maloney, Jean Carrier, and Geri Nelson.

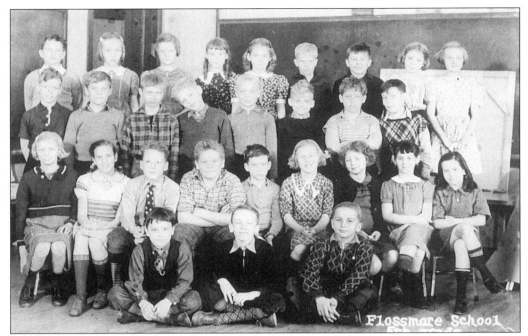

Pictured here is the Flossmoor School fifth grade class of 1938.

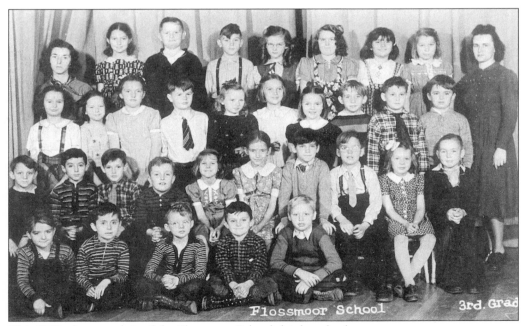

This 1939 photograph is of the Flossmoor School third grade class.

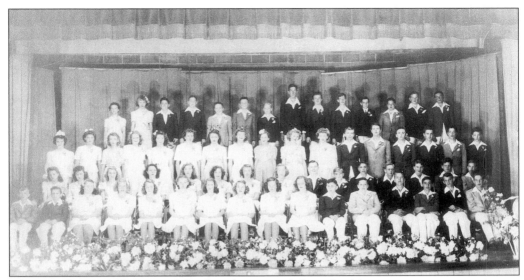

Above, is the 1944 Flossmoor School graduation eighth grade class.

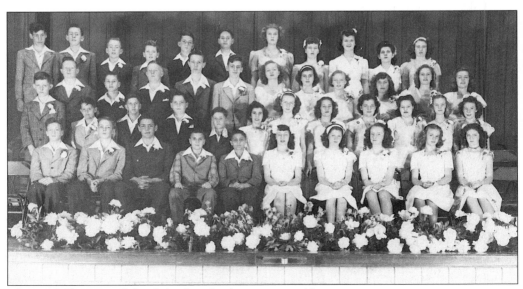

The 1945 Flossmoor School third grade class is pictured here.

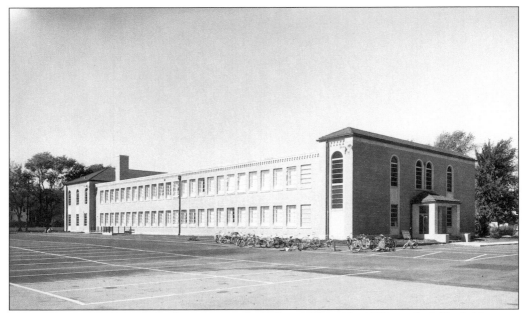

Infant Jesus of Prague School was opened on September 10, 1958, with 247 children in attendance, three years after the church was dedicated. Adrian Dominican nuns from Michigan were engaged to teach the children.

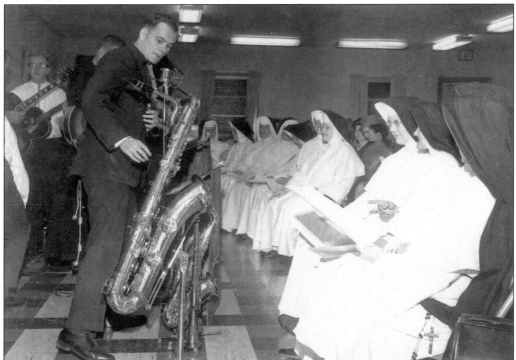

A 1966 reception honors the Adrian Dominican Sisters at Infant Jesus of Prague Catholic School.

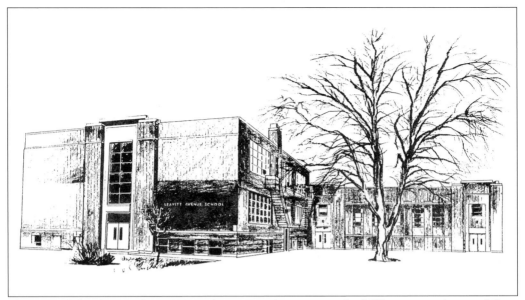

Flossmoor School opened in 1923, with just two classrooms and a full basement. A second floor was added in 1938, at a cost of $25,000. Prior to 1923, Flossmoor had two one-room schoolrooms on the outer edges of town. Both the discussion to incorporate the village, and the first meeting of the Flossmoor Community Church Sunday School took place in the basement of the school.

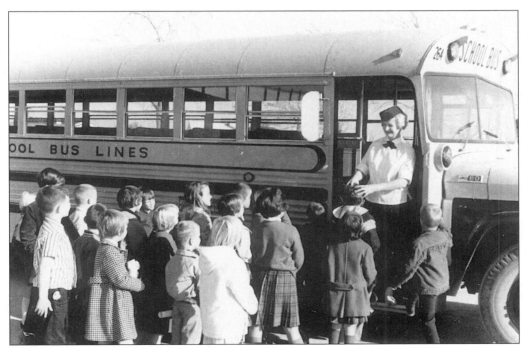

In the 1960s, school bus drivers still wore uniforms when picking up children at Western Avenue School.

In 1967, the Homewood-Flossmoor High School basketball team became one of the "Elite Eight" to play in the state finals. The team's loyal boosters had fun cheering them on in the tournament.

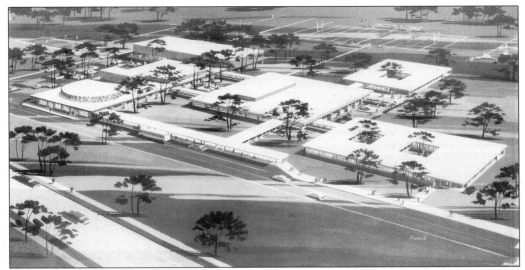

Homewood-Flossmoor High School opened in September 1959. This architectural rendering of the campus shows the wonderful facility. Two separate additions were constructed in 1962 and 1966, to accommodate the growing population of students. The school is a National Blue Ribbon award winner and ranks among the top schools in the state.

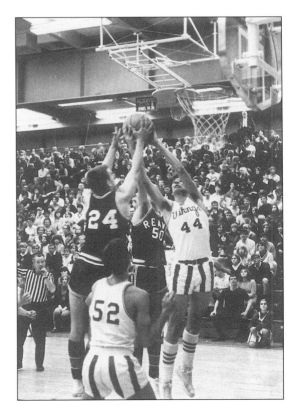

The Homewood-Flossmoor athletic teams have always been contenders. Pictured here is a Vikings basketball game against Reavis. H-F has taken state championships in every activity from girl's golf to drama.

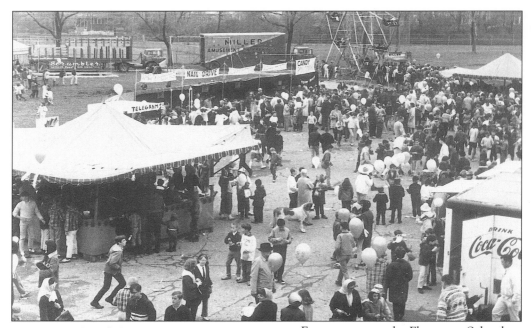

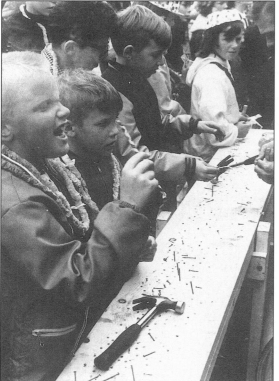

For many years, the Flossmoor School District 161 Parent Teacher Organization has organized a fun fair in the first week after school lets out. The fun fair is the PTO's largest fund-raiser of the year, and most of the money is funneled directly back into extra-curricular activities in the elementary schools. The fun fair is completely manned by parent volunteers. With rides, games, food, and crafts, it is a blast for the children. These pictures are from the mid-1960s.

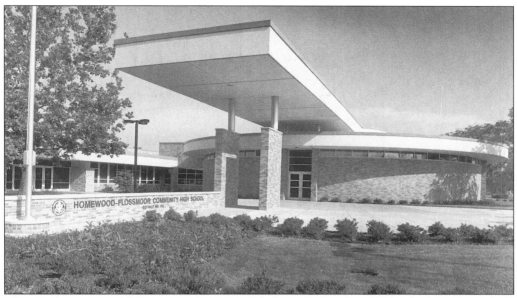

This newly constructed entrance of Homewood-Flossmoor High School is built in the style of the original architecture.

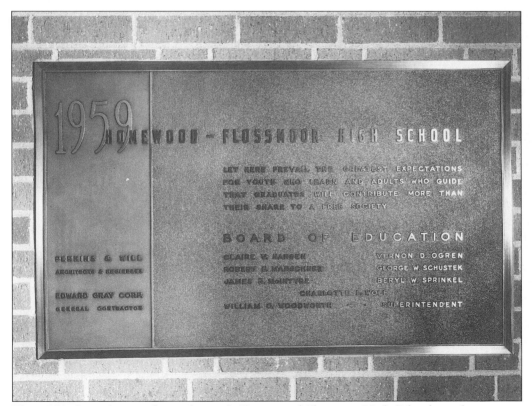

This 1959 plaque honors those who made Homewood-Flossmoor High School a reality.

These Brownie and Girl Scout troops of 1946-47 are in costume for a program in the basement of Leavitt Avenue School.

These 1949-50 cheerleaders are pictured here at Leavitt Avenue School.

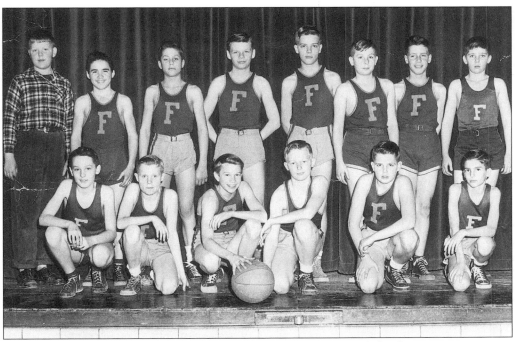

This is the 1949-50 lightweight basketball team at Leavitt Avenue School.

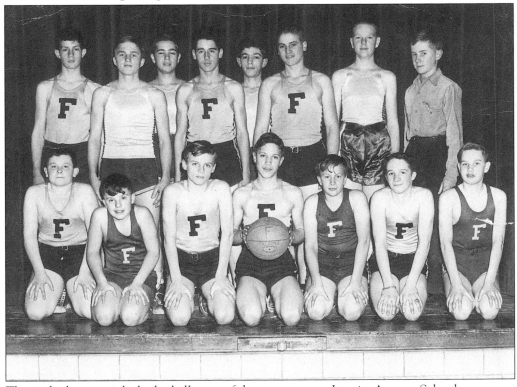

This is the heavyweight basketball team of the same year, at Leavitt Avenue School.

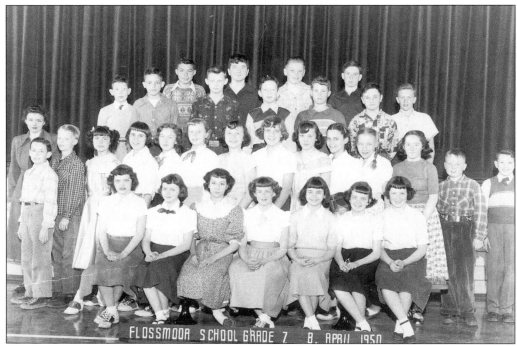

Pictured here is one of two seventh grade classes at Leavitt Avenue School in 1950.

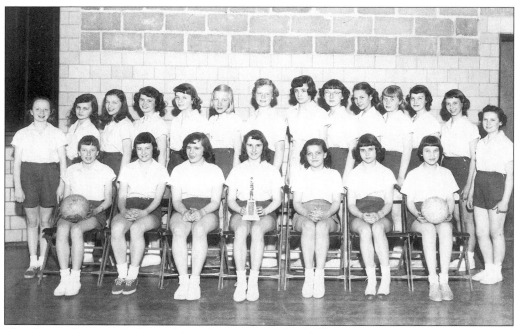

The above photograph shows the 1950-51 girls' basketball/volleyball team at Leavitt Avenue School.

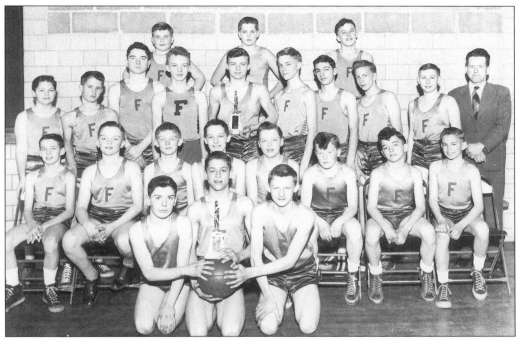

The Leavitt Avenue boys' basketball team of 1950-51 is pictured here.

This is the 1950-51 Service Club at Leavitt Avenue School.

The above picture shows the school's Girls' Glee Club of 1950-51.

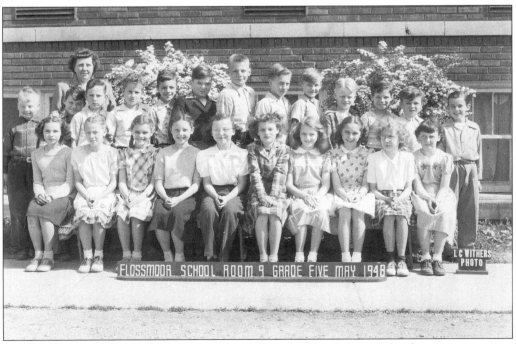

FLOSSMOOR SCHOOL ROOM 9 GRADE FIVE MAY 1948

L C WITHERS PHOTO

The fifth grade class of 1948 is photographed here at Leavitt Avenue School.

Five

CHURCHES

The first church in the village, Flossmoor Community Church, conducted Sunday school classes in the basement of Leavitt Avenue School in 1923, and formally chartered in 1927. For over 20 years the congregation met in different buildings around the village, including the Flossmoor Community House, before constructing what is today Flossmoor Community Church. Arnold Woodrich, whose father and uncles helped start the church, reports that, for many years before they could support a minister, "ministerial duties were filled by faculty from the University of Chicago Divinity School."

Flossmoor's Catholic Church, Infant Jesus of Prague, was dedicated by His Eminence Cardinal Stritch on June 24, 1955. The church building is designed in the Lombard style, complete with a campanella (bell tower), and statues made of Carrara marble. An adjoining school was opened three years later, where children were taught by the Sisters of St. Dominic from Adrian, Michigan. The church is today a pillar of education, worship, and social activity for the community.

St. John the Evangelist Episcopal Church also began services in Leavitt Avenue School in the 1920s. In the 1930s, services were held in the Civic Center, with the church eventually moving into the storefront that became St. Mary's thrift shop. The church and rectory were constructed in 1946, and under the Reverend James W. Montgomery, who later became Suffragan Bishop of Chicago, a church school building was completed in 1955.

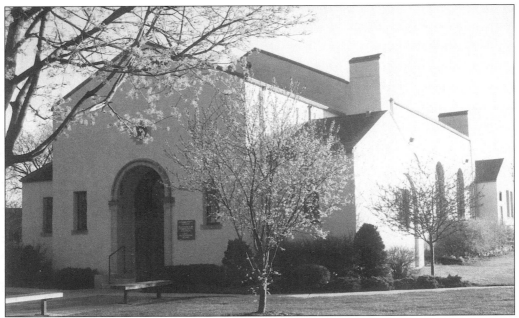

The Flossmoor Community House was originally built as a social center for residents of the Flossmoor Park neighborhood. However, in 1933, the community church rented it for services, and eventually bought it from the Phipps estate for $1.

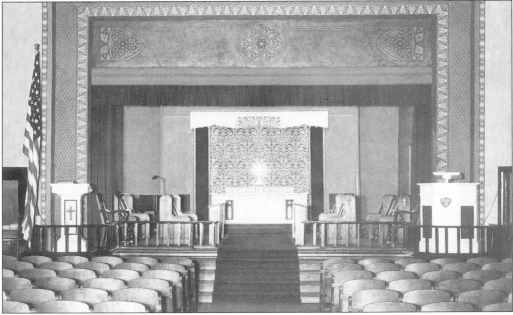

This 1934 picture of the proscenium of the community house shows the interior as it appeared when the Flossmoor Community Church held its services here. The stencil work was done by Flossmoor resident Fred Vanderwalker to give the building "a dignified character, to make it look somewhat like a church, and it did," writes Mrs. Vanderwalker in her memoirs. Later, Douglas Hall did three wood carvings that are well known throughout the community.

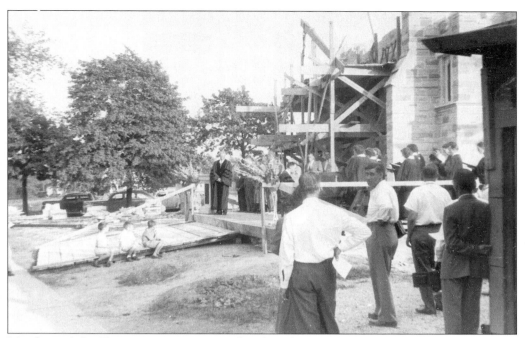

Members of the Flossmoor Community Church gather for the groundbreaking ceremony for their new church in 1948. An educational wing was added in 1955.

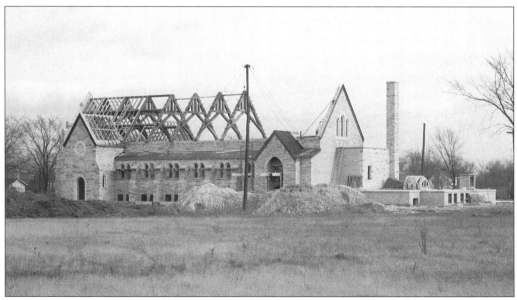

Flossmoor Community Church is pictured under construction in 1948.

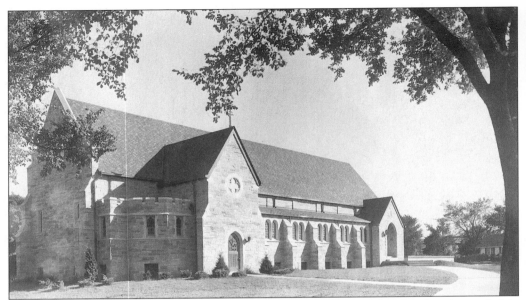

Two views of Flossmoor Community Church reveal its majesty. Today the church, nestled in the heart of the Flossmoor Park neighborhood, serves the community with a preschool.

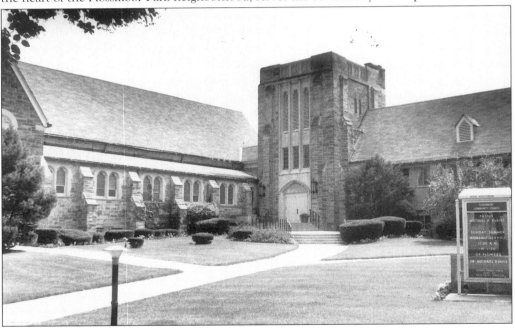

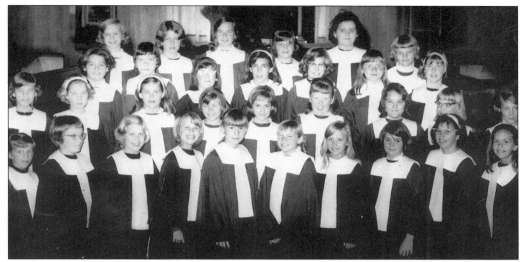

The 1955 Flossmoor Community Church girls' choir is photographed here.

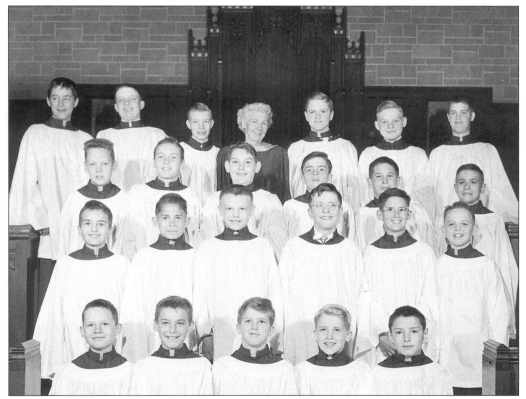

The Flossmoor Community Church boys' choir, of the same year, is pictured above.

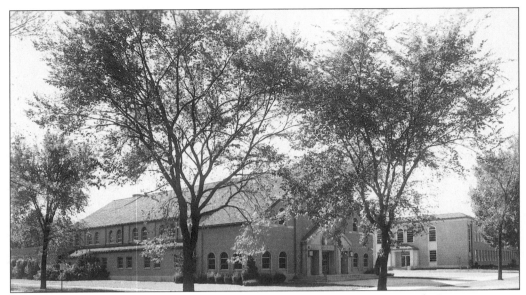

Infant Jesus of Prague Catholic Church was completed in 1955. Spanish Renaissance in architecture, the church cost $350,000. The parishioners did not wait for the church to be completed to hold their first Mass at Christmas in 1954. The inside of the church was barren, with a mud floor, a makeshift altar, and swaying light bulbs. However, to the parishioners, the atmosphere was a reminder of the stable of Bethlehem.

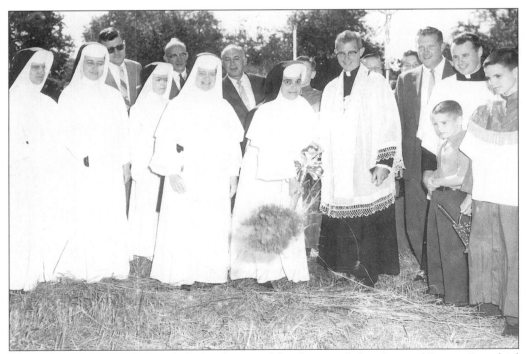

The Adrian Dominican nuns help break ground for the new Infant Jesus of Prague Parochial School in 1958.

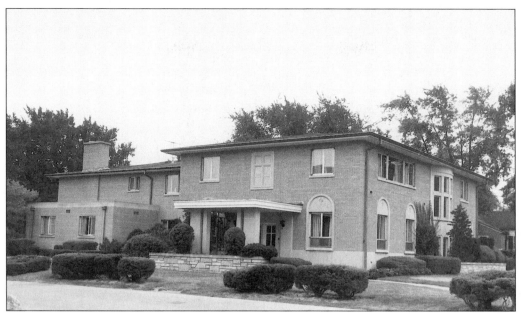

Infant Jesus of Prague Catholic Church rectory was finished in September of 1963, and was built to harmonize with the church's Lombard style.

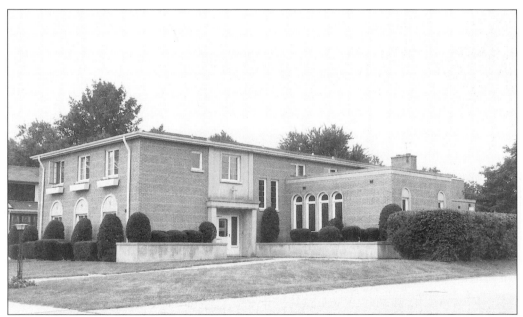

Infant Jesus of Prague Convent for the Adrian Dominican nuns was completed in May of 1961. The final church building to be constructed was the parish center, which consists of a meeting hall that serves as a cafeteria for the schoolchildren, and a second-floor gymnasium. The church, rectory, school, and convent on Flossmoor Road give Flossmoor a peaceful and lovely campus in its center.

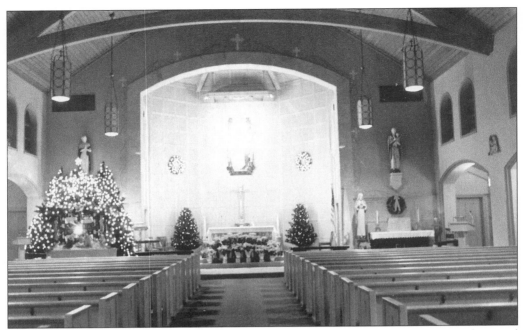

Infant Jesus of Prague Catholic Church, is decorated here for Christmas, in 1959. The wood paneling of combed white oak all came from one South American tree. Vincent Trabucco, owner of the Steger Piano Company, was responsible for getting the tree. The Stations of the Cross were made of wood in Bavaria and were donated by individual families.

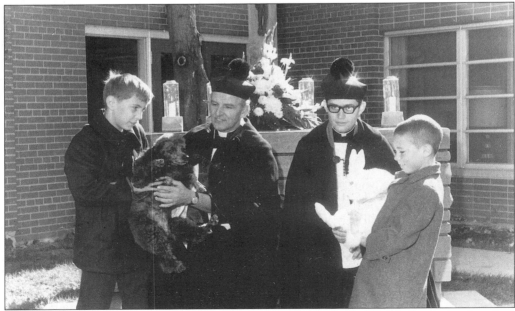

In 1966, two assistant priests provide the annual blessings of the children's pets at the church of St. John the Evangelist, at Leavitt and Park Avenues.

This is St. John the Evangelist Episcopal Church as it appeared in the 1940s. The church had been meeting in a storefront in the Civic Center. Today the church is surrounded by old growth landscaping, and has an educational wing where residents bring their children for preschool.

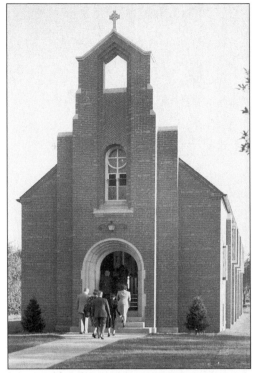

Priests and lay leaders celebrate burning the mortgage at St. John's Church. The mortgage was paid off in 16 years because of the success of the St. Mary's Guild Thrift Shop. The Thrift Shop then directed half of its profits to the Episcopal Charities.

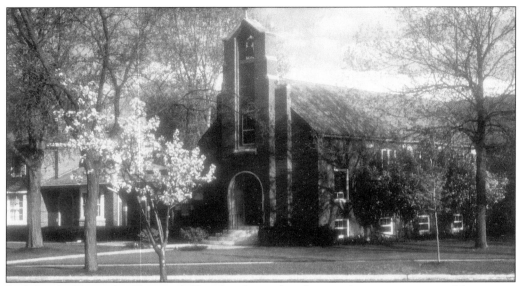

St. John the Evangelist Episcopal Church is located on Leavitt Avenue, just west of downtown Flossmoor. It is among some of Flossmoor's most beautiful homes and is across the street from Leavitt Park.

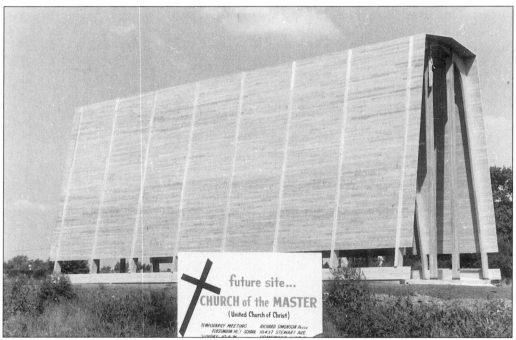

The Church of the Master is pictured here, during construction, in 1966. This church is now the Cathedral of Joy, and serves Flossmoor and the surrounding communities, along with Infant Jesus of Prague Catholic Church, Flossmoor Community Church, St. John the Evangelical Episcopal Church, Bethel Evangelical Covenant Church, the Anita M. Stone Jewish Community Center, the Korean United Methodist Church, the Calvary Temple, and the Reorganized Church of Jesus Christ of Latter Day Saints.

Six

FAMILIES

The history of Flossmoor is a story of families: the German immigrant families that first settled the land and the Chicago families that took the train to Flossmoor for golf and leisure. In many cases, Flossmoor's geography is still divided along the property lines of the first families. The Nietfeldts worked the land on the southeast corner of Flossmoor Road and Kedzie Avenue, which is now the Heather Hill subdivision. The Hecht family owned property that later became portions of the Flossmoor Country Club and the Dartmouth neighborhood.

For many of the families that came to Flossmoor in the 1920s to escape the big city, their first experiences were quite spartan. . . and muddy. Spencer Irons writes, "the house, constructed in 1922, had been designed by Henry Holsman to be built in stages, the first stage to be only a shell for summer living with the barest of interior amenities." Laura Catherine Vanderwalker recalls visiting their new property on Holbrook Road in 1917: "That night there was a *terrible* storm, which flattened the temporary tent. Our new neighbor, Mary McKnight, came out to offer us her wood shed for shelter."

Especially during the Depression, many families' commitment to Flossmoor was tested. Geri Aron writes, "I have very few memories of the Gardner Road house as the Depression crushed my parents' dream of spending long, happy years in their new home." Nevertheless, families stayed in Flossmoor through those tough years to raise their children, generation after generation.

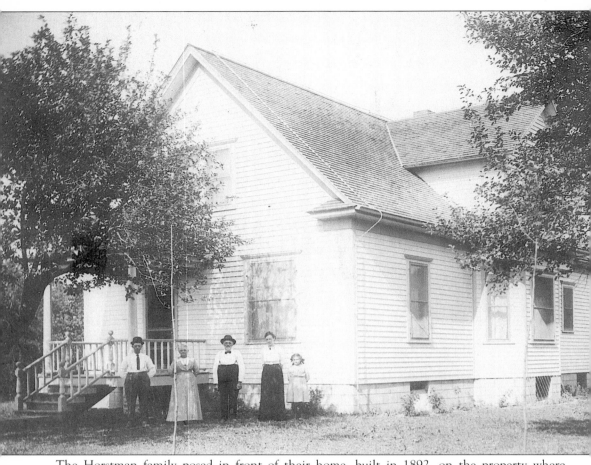

The Horstman family posed in front of their home, built in 1892, on the property where the Homewood-Flossmoor High School now stands. The house was moved to Flossmoor Road in 1924.

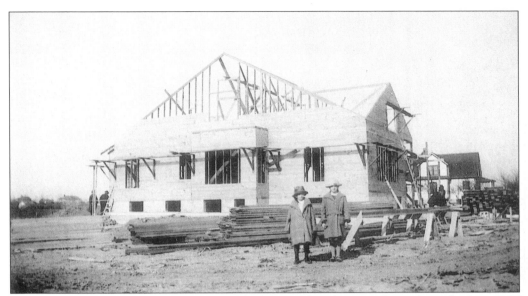

Hilda Hope and her friend Malinda Riegel look forward to the Hope home being built at 2835 Flossmoor Road.

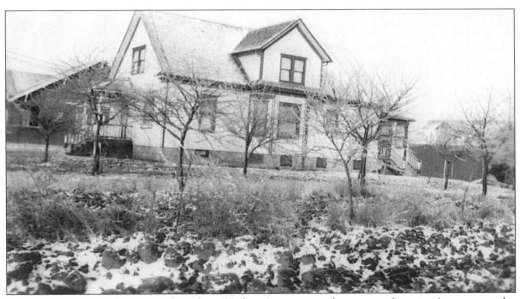

In 1847, a 116-acre lot, extending from Kedzie Avenue on the west to Leavitt Avenue on the east, was given by the U.S. government to a man as a reward for serving as a Tennessee volunteer. This unknown man never lived here but sold it to the Hope/Horstman family in 1854. The Horstman home was later moved to 2831 Flossmoor Road.

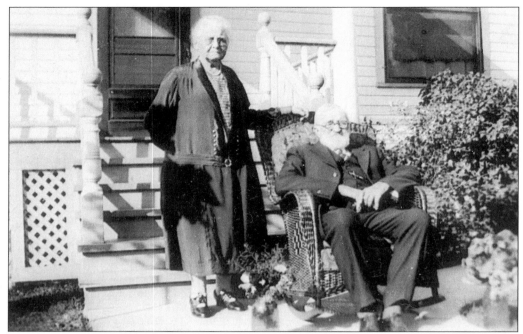

Emma Horstman is pictured in front of her home, now located at 2831 Flossmoor Road.

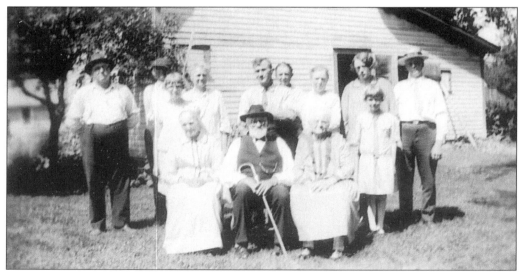

Emma Horstman (seated far right) and Henry Horstman (top right), are gathered for a family photograph in 1924, in front of their Flossmoor Road house.

Ida Horstman and Amanda Hemlonke are photographed here at their Flossmoor Road home.

Hilda Hope is "king of the woodpile" at the Nietfeldt's farm, on the southeast corner of Kedzie Avenue and Flossmoor Road.

Hilda Hope gives her baby doll a ride in the yard of her home on Flossmoor Road.

Hilda Hope is pictured in the backyard of her home at 2835 Flossmoor Road.

Hilda Hope poses in the side yard of 2825 Flossmoor Road.

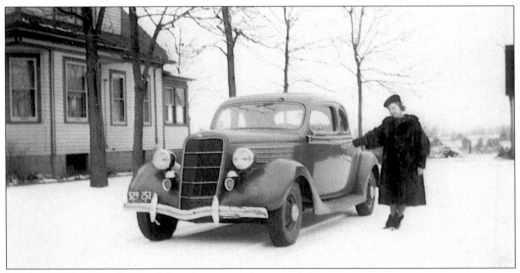

Hilda Hope looks stylish with her fur coat and automobile.

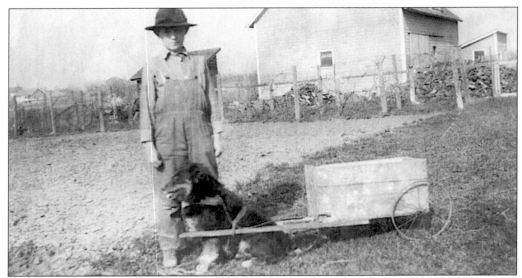

Harry Wallenberg pressed his dog into service. The Wallenburgs were first cousins of the Hope children and lived next door, at 2835 Flossmoor Road.

Harry Wallenberg cuts a dashing figure in front of his Flossmoor Road home.

Two Wallenberg cousins are posing here with their car.

Fred Wallenberg and his brother are standing in their well-tended yard.

An early snowplow is shown working on Flossmoor Road.

Hilda Hope and a friend enjoy the winter snow at their home, located at 2831 Flossmoor Road.

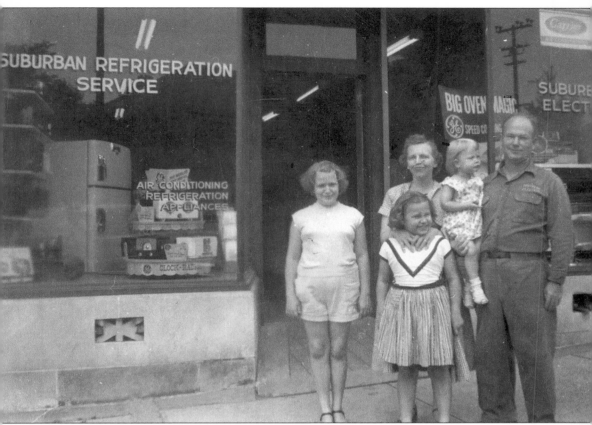

Carl Hope, holding his daughter Patty, is surrounded by his family in front of their business in 1952. Carl began Suburban Refrigeration in his Flossmoor Road home and later moved into a store in the Civic Center in downtown Flossmoor. Patty Hope grew up to marry Michael Krokidas, who renamed the business Suburban Electric. Suburban Electric is still a thriving business in Homewood, run by Michael and Patty, who live in the old Hope home on Flossmoor Road.

Otto and Bert Hecht are pictured by the family farmhouse that stands today at 18916 Dixie Highway. Albert Hecht bought up large parcels of land that were later sold to the Flossmoor Country Club. The Hecht home on Dixie Highway was reportedly moved to its present location from land sold to the club.

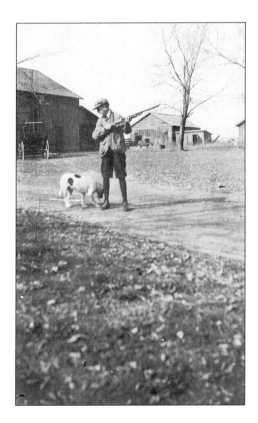

Bert Hecht is hunting with his dog on the family farm, now located at 18916 Dixie Highway.

Pictured is the first Nietfeldt homestead, located on Flossmoor Road, near Cherry Hills golf course. This scene was photographed in the 1800s.

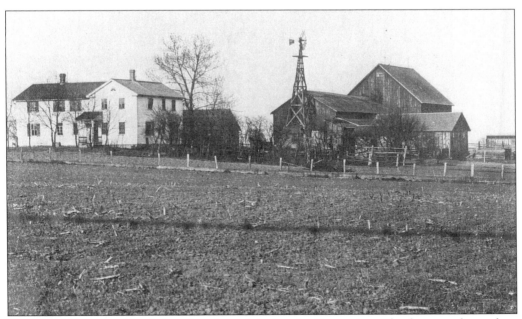

The Nietfeldts rented land that they farmed during the Depression. The farm was located on the southeast corner of Flossmoor Road and Kedzie Avenue, in the area that is now the Heather Hill subdivision. Descendants remember the farm as "Mail Route Box 16."

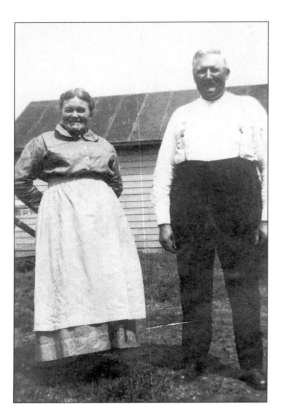

William and Dorothia Nietfeldt had nine children. William, a farmer, was also the road commissioner who supervised the building of Kedzie Avenue. "Kedzie was originally a horse trail that was simply paved over, preserving its rolling hills," explained Dora Nietfeldt.

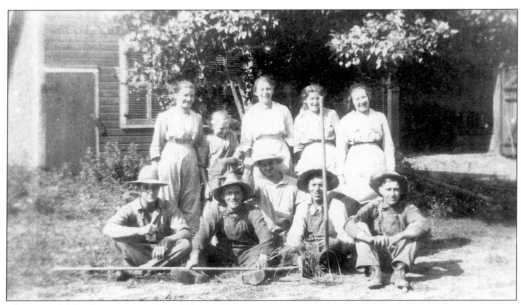

The Nietfeldt clan enjoys a break from farming.

This is the first generation of Nietfeldt women.

In 1918, Dora Nietfeldt's class picnic was held on the property that is now Homewood-Flossmoor High School.

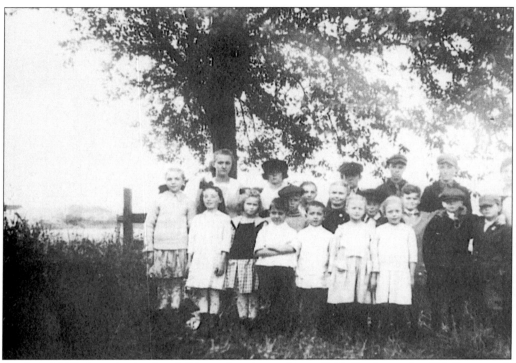

At their 1918 class picnic, the children played near Butterfield Creek, south of Vollmer road, on property that was later sold to the Olympia Fields Country Club.

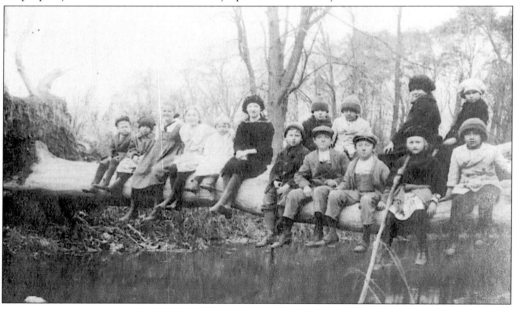

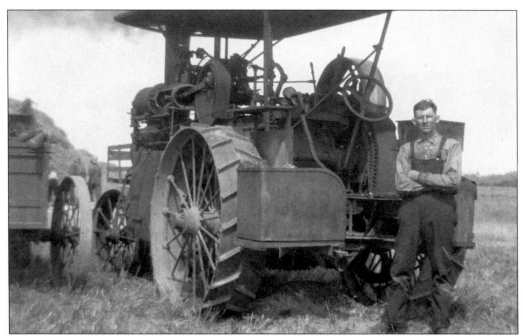

August Nietfeldt poses in front of the family's first steam-engine tractor.

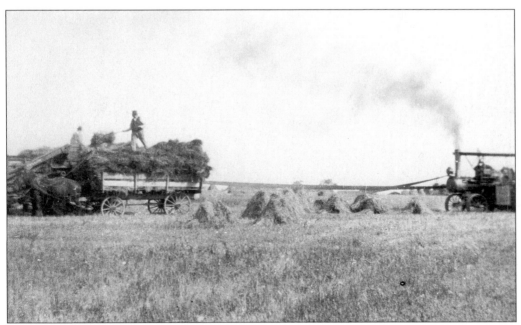

Bundling the hay is the activity shown in this photograph of the Nietfeldt farm.

The Nietfeldt men had to open the road with horse-drawn plows when it snowed on Emma Nietfeldt's wedding day, April 4, 1926.

Theodore Nietfeldt and Herman Woehrle are posed with the Nietfeldt's first automobile.

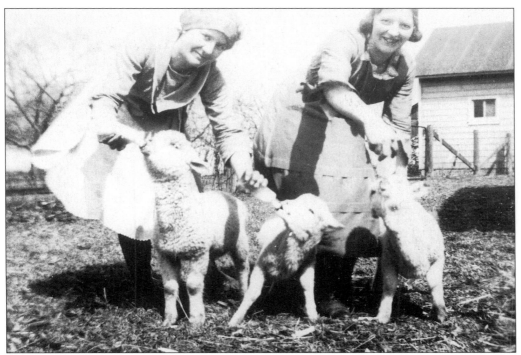

The Nietfeldt farm offered wonderful activities for the children. These girls were asked to care for the lambs in 1923.

Dorothia, Dora, and Minnie Nietfeldt tour the World's Fair in Chicago in 1934.

Joe Ives, Wayne Johnston, Opie Pauling, Doug Stewart, and Bruce Harlan hang out at the Civic Center in 1943.

Seven

HOMES

The earliest homes in Flossmoor were farmhouses of the German immigrants who came to the area in the mid-1800s. By the beginning of the 20th century, however, homes were being built in Flossmoor as summer cottages for wealthy Chicagoans. In *The Early Years*, Flossmoor resident Spencer Irons writes of his parents' home, constructed in 1922: "The character of the house as a summer residence was illustrated by the fact that there were two screened porches . . ." Many of Flossmoor's historic homes are marked by wide, wrap-around porches.

These summer "cottages" were designed in the contemporary styles of the 1920s and 1930s. Indeed, one of these homes is an authentic Frank Lloyd Wright design, and many other homes are designed in the Prairie School of architecture by leading Chicago architects.

"The most important part of the Flossmoor place, for my father at least, was the garden," Spencer Irons writes of his family's summer home in Flossmoor. Likewise, Catherine Adams Vanderwalker, who moved to Flossmoor in 1917, writes in *Our Years*, that her husband Fred was "buying and planting raspberries, strawberries, grapes, currants, apple trees, pear trees, cherry trees, crabapple trees, bushes, wisteria, and peach trees. . ." From these early gardeners, Flossmoor is still graced with a fabulous array of flowering spring trees.

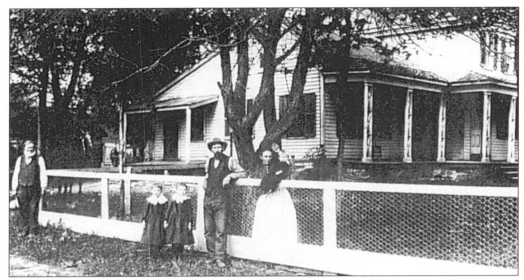

Conrad Hecht's home was one of the first houses in Flossmoor. The Hechts farmed large parcels of land in Flossmoor that were eventually sold off to create Flossmoor Country Club and the surrounding neighborhoods. The Hecht family remained in the community for many years, owning a grocery store in downtown Flossmoor from the 1920s to the 1940s.

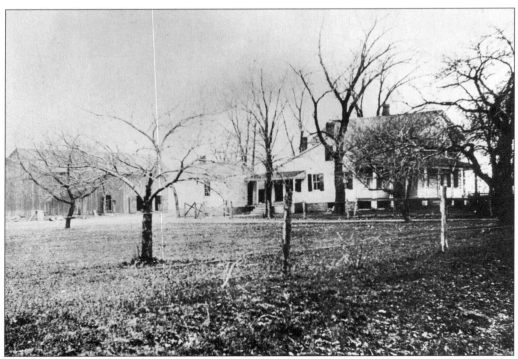

The Hecht home still stands at 18916 Dixie Highway, just north of Flossmoor Road.

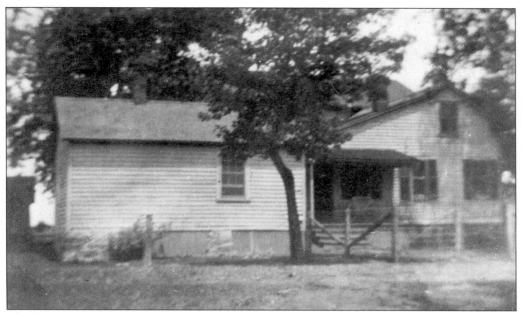

The house has been remodeled and has had additions built over the years, but it still evokes its historic charm.

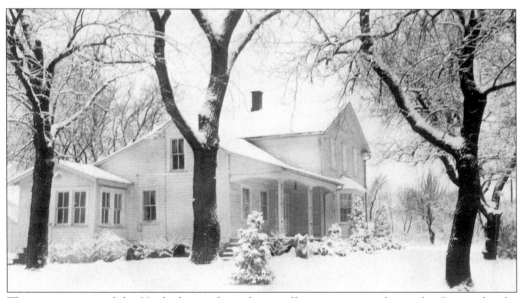

This winter view of the Hecht home shows how well its current residents, the Serviss family, have maintained it.

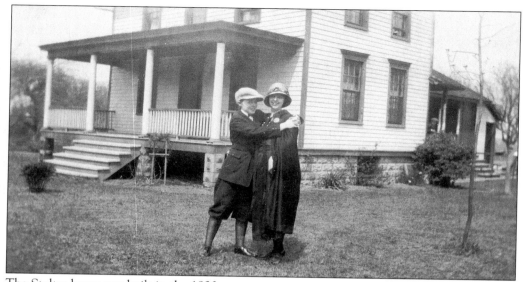

The Stelter home was built in the 1920s.

Arthur and Minnie Nelson built this house on Gardner Road in 1920, and later lost it during the Depression. Their daughter, Geri, married the son of the police chief, Opie Pauling.

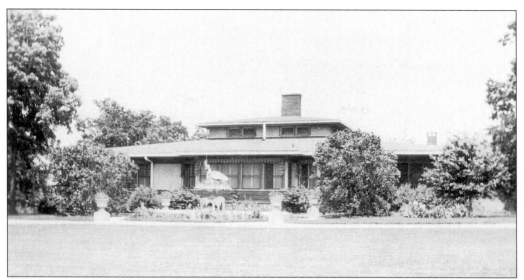

This home was built by Henry L. Newhouse, a great admirer of Frank Lloyd Wright. It was built as the summer home of Adolph Linick, at the corner of Holbrook Road and Dixie Highway in 1923. Behind the photographer stood a companion home, which was later moved to Sylvan Court. Mr. Linick and his partner, Aaron Jones, owned a large theatrical firm in Chicago.

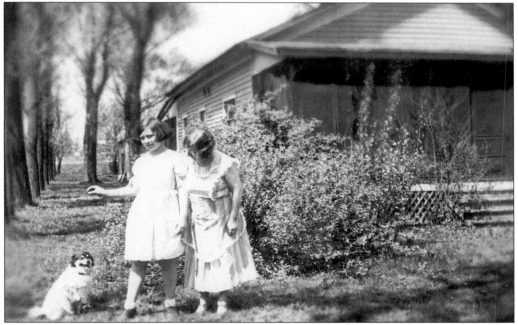

This 1931 picture shows the Nelson cottage on Braeburn Road, with Geri Nelson and a friend in the side garden.

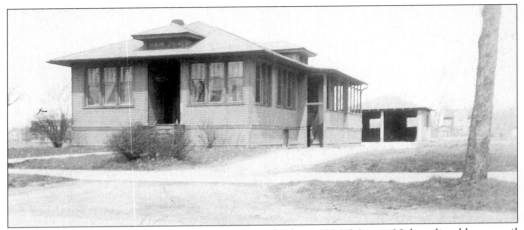

This home, located at 2633 Flossmoor Road, was built in 1936. Minnie Nelson lived here until her death in 1966.

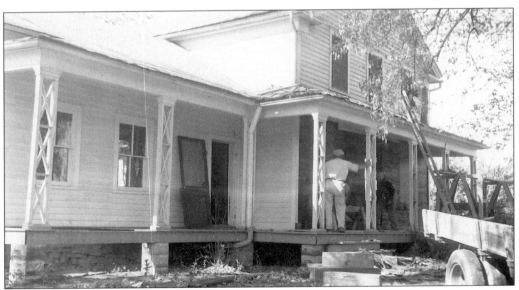

The Hecht home is shown during remodeling in 1940.

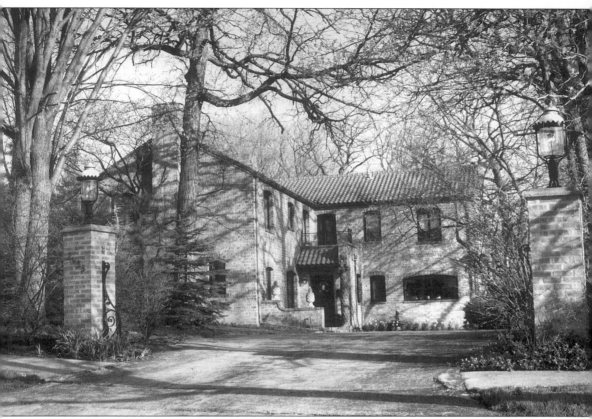

This lovely home, with a ceramic tile roof that is characteristic of many original Flossmoor residences, was built in the early 1920s as part of the Horton estate. Mr. Horton was founder of Chicago Bridge and Iron Co., known today as CBI Corporation in Oakbrook, Illinois. Mr. Herbert List has lived in the home for nearly 30 years.

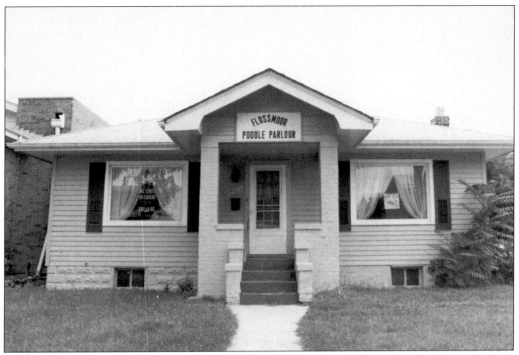

The Poodle Parlor on Flossmoor Road was a Sears Roebuck and Co. mail-order house built in the early 1940s. It was a private home, until the last 20 years, when that area of Flossmoor Road became commercialized.

This home epitomizes the characteristics of the early Flossmoor summer homes; it is a big house that features a large porch.

This home, designed by Frank Lloyd Wright, is at 1136 Brassie Avenue. The home was contracted to Frederick Doveton Nichols Sr., a Chicago-area promoter of the Como Orchard and Bitter Root projects in Montana. Nichols used the home as a summer getaway for golf on the weekends. Genevieve and Melvin Evans later lived in the house for 52 years, adding the southeast porch and replacing the siding in 1933.

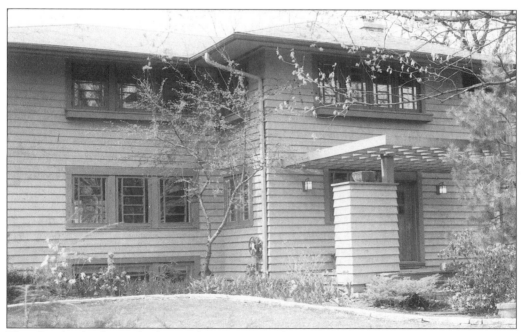

This Frank Lloyd Wright home shows many of his signature design features. Known as a "Fireproof House" design, the entry stairwell is half within the house and half outside. The house also displays the characteristic roof line and overhangs of Frank Lloyd Wright.

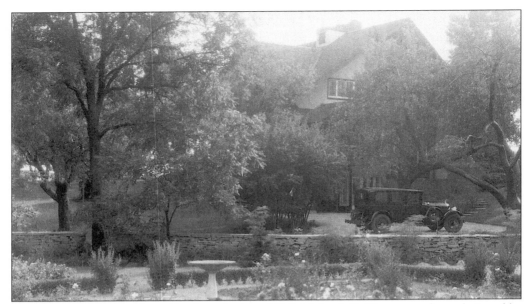

This home at 1441 Braeburn Road was built in 1916–17 for A.H. Hunter, and was designed by the world-famous architectural firm of Purcell and Elmslie. Purcell and Elmslie were known as the designers of commercial buildings in the Prairie School of design, and this home is one of only a few residences designed by the firm.

The house is a classic example of the Prairie School of architecture, popular from 1900 to World War I. Characteristically, the house has broad, gable roofs with wood and stucco siding, and built-in couches, cabinets, tables, and bookcases. All the lumber used to construct the home was four inches by six inches, rather than the standard two inches by four inches.

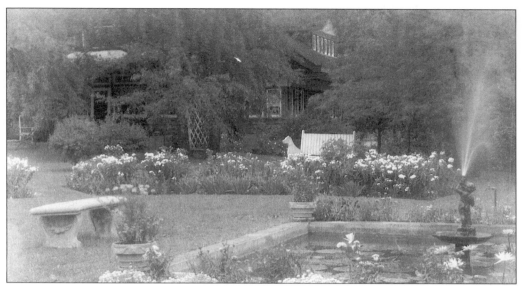

The property was beautifully landscaped and had a natural creek running through it that fed into Butterfield Creek. The rose gardens and statue still adorn the home today.

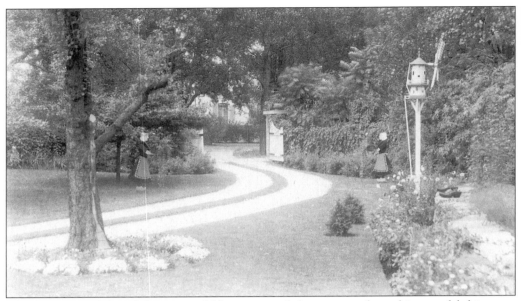

The first automobiles of the era would have entered the property from this graceful driveway, passing Dutch ornaments along the way.

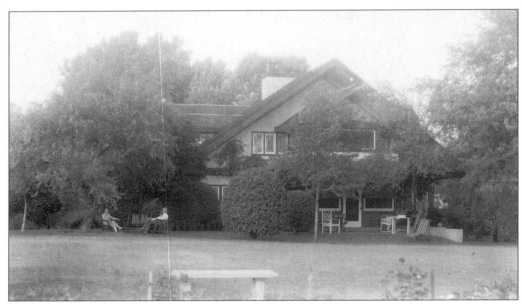

The home at 1441 Braeburn features unique, leaded-glass windows that displayed a flower pattern repeated in every window. The windows and blueprints of the home were shown at the Chicago Museum of Art several years ago.

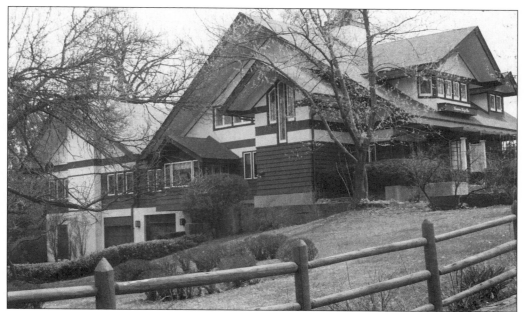

The home at 1441 Braeburn is now owned by Dr. Steven and Anna Soltes, who made an addition to the home pictured on the left. To ensure the addition reflected the style of the original Prairie School of architecture, the Soltes used the architect who restored the Frank Lloyd Wright studio in Oak Park, Illinois. The addition is a "great room" in line with that period of design, and the Soltes had exact replicas of the original leaded-glass windows made by hand for the addition.

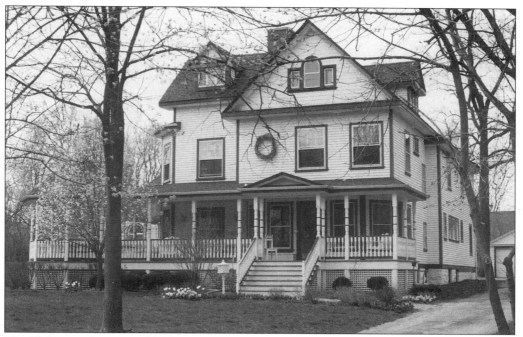

The Blakemore home at 1222 Brassie Avenue was built by the Gilchrist family in 1890.

This is a 1940 view, from the village up Park Drive and Argyle Avenue, of the newly-built Munro house.

This 1940 view, from the east side of Argyle Avenue, looks west along Park Drive. Leavitt Avenue School is in the background.

These homes are on the corner of Park Drive and Argyle Avenue, looking at houses on the east side of Argyle Avenue. In the background is a house on Sterling Avenue. The photograph gives the feeling of a new subdivision, whereas this neighborhood now boasts old-growth trees and lush landscaping.

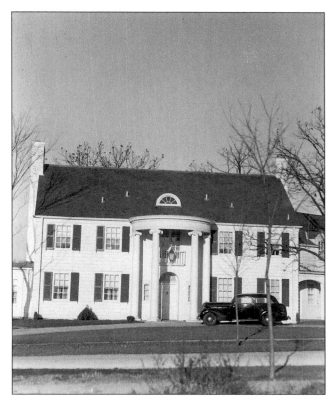

This house, built in 1938, faces south on Braeburn Road, almost at the corner of Brassie Avenue. For many years, it was the home of Wayne Johnson, president of the Illinois Central Railroad, who was largely responsible for bringing the train service to Flossmoor.

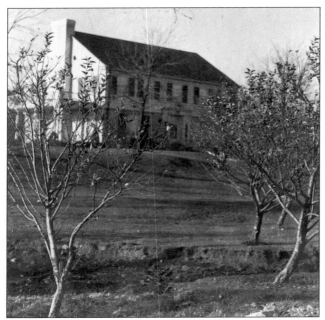

Built in 1922, this lovely signature home in Flossmoor graces the hill at the corner of Brassie Avenue and Braeburn Road. Pictures from 1943 and the present show how the home has matured over the years.

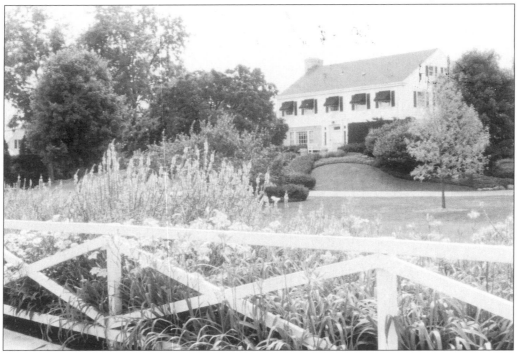

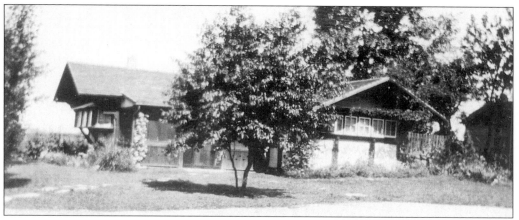

This is the home of Mr. and Mrs. Robert Zell on Braeburn Road (above) as it appeared many years ago. Below is a present-day view of the home. The original house was a small, summer house that was built before 1920. About 1926, Mr. Kennicott, a builder and architect, moved the original wing forward and built another wing. He gathered things for the house from old homes in Chicago Heights, Illinois. Inside the house, there are crystal doorknobs, marble window sills, and random-width mahogany flooring in the library. On the outside is a gaslight lamp post, taken from Chicago Heights when the city changed from gas to electricity. Kennicott was a bit of a character, and he enjoyed adding on to the house and finding unusual furnishings.

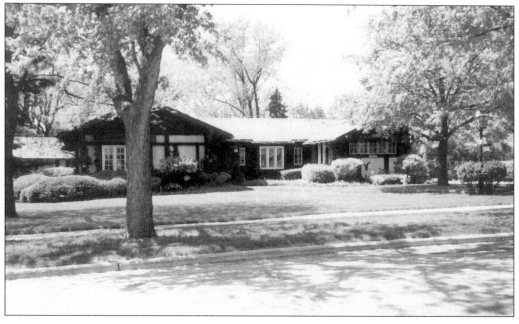

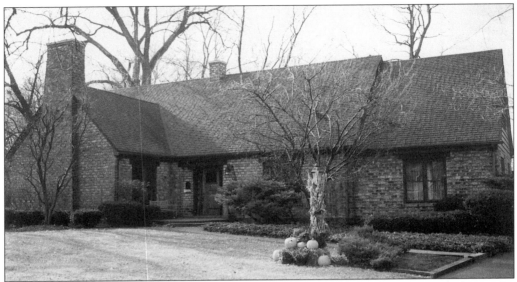

This Flossmoor home was built in 1925 by Mr. and Mrs. Robert Echols. Mrs. Echols was the grade school principal and later post-mistress at the train station. Mr. Echols was a chemist for Sherwin Williams and an amateur horticulturist who cross-pollinated peonies. Both were from Texas, and Mrs. Echols was a descendent of Sam Houston, whose six-by-eight-foot portrait hung over the fireplace.

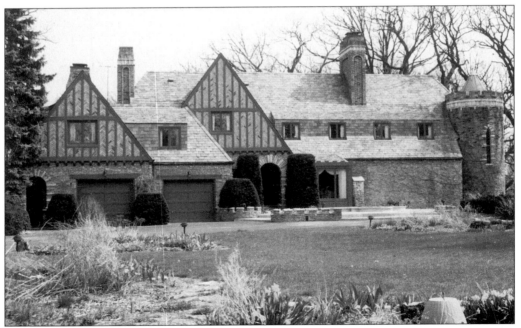

The gabled, Tudor-style architecture of the downtown Civic Center is reflected in many Flossmoor homes.

Eight
CIVIC ORGANIZATIONS

The feeling of closeness and community that residents of Flossmoor enjoy is exemplified by Flossmoor's many civic organizations. The attraction of the Flossmoor Country Club originally drew Chicagoans to the beautiful setting of Flossmoor. As neighborhoods grew, residents came together for education and public service in book groups, service organizations, and social clubs.

Laura Catherine Adams Vanderwalker remembers in *Our Years*: "'The Literary' was a group of people who thought it fun to read and learn. We were required to give a program of 'literary' significance every so often. . ." In 1953, a group of women created the Flossmoor Service League, which raised money for local charities by organizing an annual tour of several of Flossmoor's most lovely homes.

In 1964, local artists formed the Village Artists for the advancement, promotion, and study of art. Today, the Village Artists continue to offer art instruction and organize exhibits. Recently, an anonymous donor gave a significant amount of money to the village to fund public art and gardens. This desire to broaden horizons, reach out, and do good still permeates the Flossmoor community, with citizens dedicated to first-rate schools, a blue-ribbon park district, and giving back to the community.

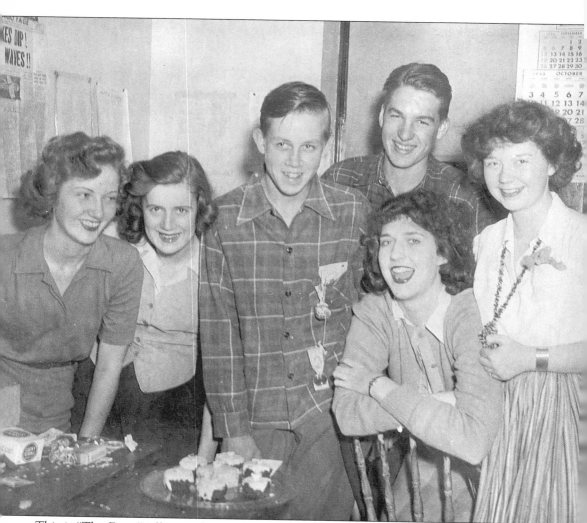

This is "The Dope" office in the Civic Center building, pictured in 1943. "The Dope" was a monthly newsletter written and edited by young students for the boys from Flossmoor who were away in the service. The office was also a meeting place for the servicemen who came home on leave. "The Dope" staff members were Barbara Vanderwalker, Phyllis Ogden, Bill Brostrom, Bud Foster, Sallie Van Buren, and Geraldine "Geri" Nelson.

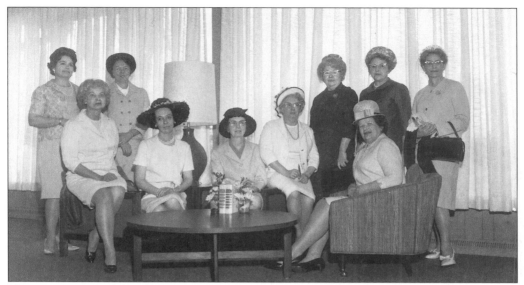

This is a meeting of the Flossmoor Book Club in the 1950s. Berneice Taylor, seated far right, is shown as the new president.

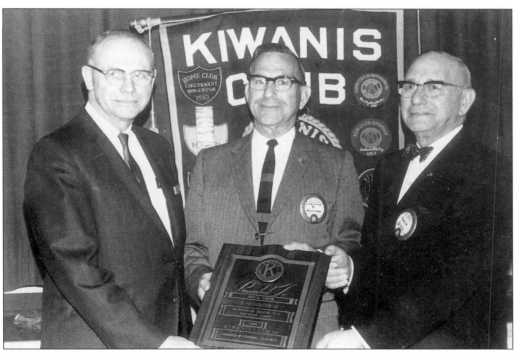

This public service plaque was given by the Kiwanis Club to John Harper (left) in 1966.

The membership of the Flossmoor Women's Club welcomes new members at a tea party in 1966.

A women's group gathers gifts for Vietnam soldiers at Christmas in 1959.

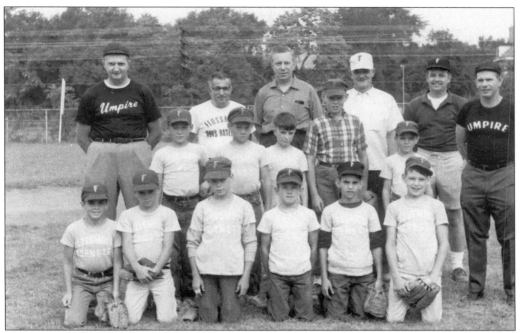

The Flossmoor triple-A baseball team is shown here at the Little League field in 1966.

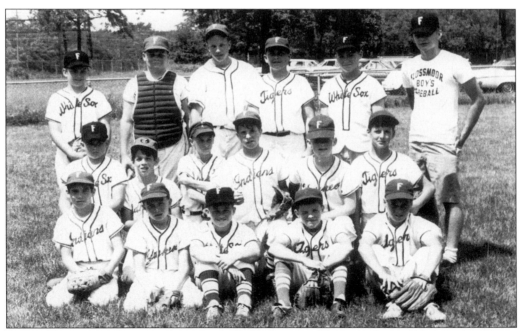

Pictured here is the Flossmoor boys' baseball all-star team. Flossmoor baseball leagues have been a cornerstone of growing up in Flossmoor for many years. Staffed by parents, the league involves children from age five to adolescence. The league continues to be a way for families to come together and enjoy their community.

This is the Homewood-Flossmoor High School baseball team. The community's commitment to children's baseball results in winning teams for the high school.

Above are junior golf award winners at the Flossmoor Country Club. Area country clubs, including Flossmoor, Idlewild, Ravisloe, Olympia Fields, and the Homewood-Flossmoor High School have produced some excellent amateur golfers.

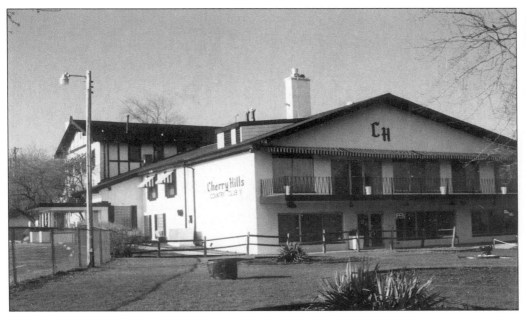

Cherry Hills Country Club was built on beautiful land just west of Kedzie Avenue in the 1920s. Today, Cherry Hills Country Club is open to the public and is known for serving a great breakfast.

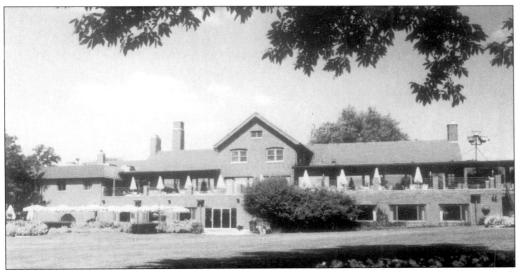

The Flossmoor Country Club was built in 1900 on the north side of the property, but was struck by lightning and burned to the ground in 1904. A new clubhouse opened in 1908, built of brick and cement, but again burned down when the wooden rafters were set ablaze by lightning in 1914. Today's clubhouse, built in a different location, was constructed in 1915. The attraction of the club was one of the main reasons for the Illinois Central Railroad extending its train service to Flossmoor. "On Saturday and Sunday mornings, the I.C. operated several trains designated 'Golf Specials,' each carrying several hundred golfers who would be met by buses from their respective clubs," recalls Flossmoor resident Spencer Irons.

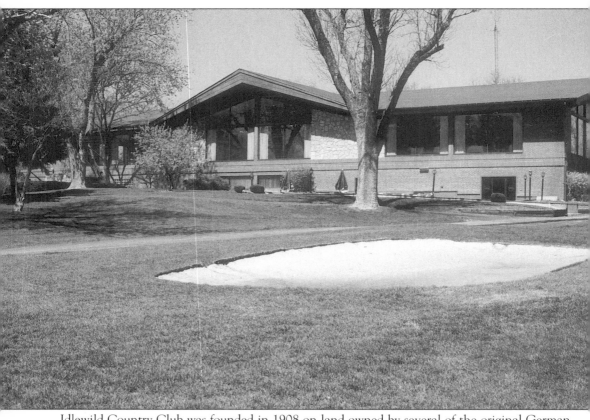

Idlewild Country Club was founded in 1908 on land owned by several of the original German settlers, on the east side of Dixie Highway.

Nine

FOURTH OF JULY PARADE AND WAR MEMORIAL

Every year, Flossmoor's traditions of family and community are celebrated with the children's Fourth of July Parade. The first Fourth of July parade took place in 1931. The idea for the parade was conceived by Nina Peasly and Laura Vanderwalker. Warren Peasly, commander of the American Legion, suggested the Legion sponsor the parade. Fred Vanderwalker was in the paint and stencil business, and made many of the wonderful floats during those early years.

For many years, the parade has been sponsored by the Flossmoor Fire Department. Each year, the fire engines lead the children east on Flossmoor Road to Sterling Avenue, where they end up parading around the downtown traffic circle, in front of the historic train station. There, a community band made up of high school students and local musicians plays patriotic music, led by the high school bandleader. The fire engines are on display and the volunteer firefighters give a safety demonstration. The fire department provides refreshments and ice cream for the children and awards prizes in many categories.

"The war memorial was dedicated on Easter Sunday, April 1, 1945," former resident Dick Condon reported in his history of the Civic Center. The Honor Role was erected by the local American Legion, but no longer stands in downtown Flossmoor. Mr. Condon states that 146 men and 9 women were in the armed services during the war, with 6 residents dying in the war effort.

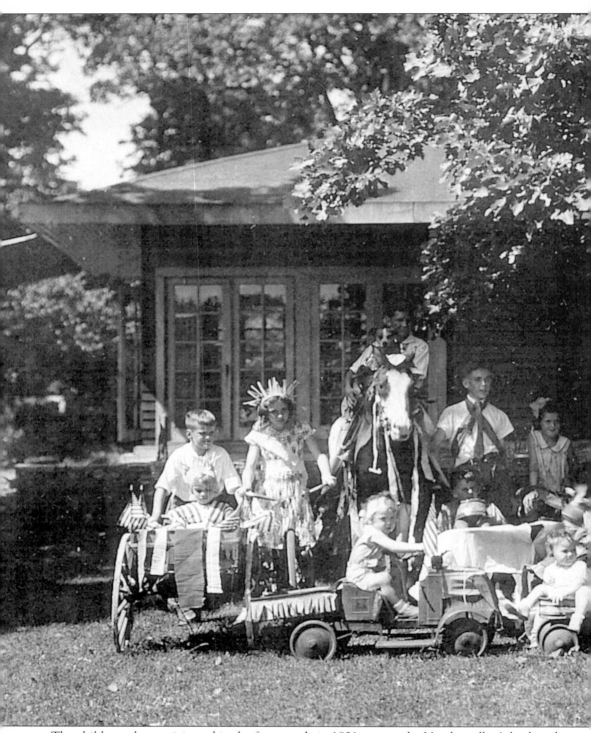

The children who participated in the first parade in 1931 pose in the Vanderwalker's backyard. Warren Peasly, Commander of the American Legion, suggested they sponsor a parade, and "so

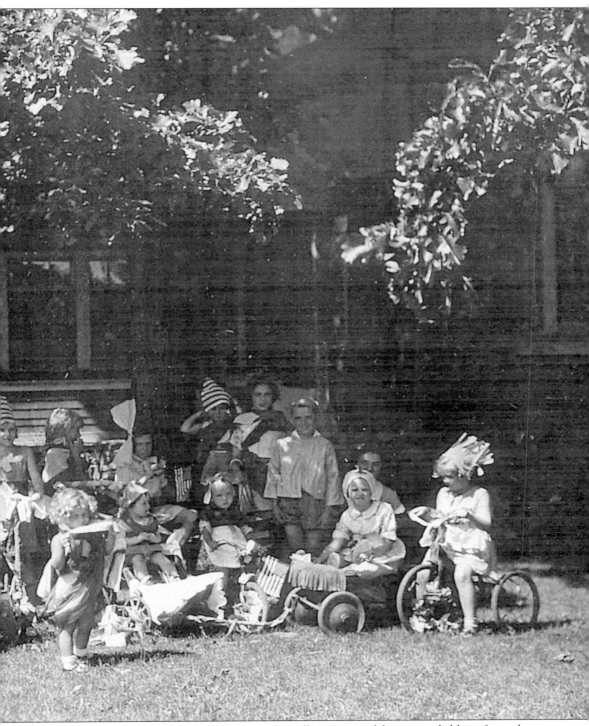

it was done, forever after," writes Laura Vanderwalker. Pictured here are children from the Vanderwalker, Hamilton, Hall, Deveneau, and Huston families, among others.

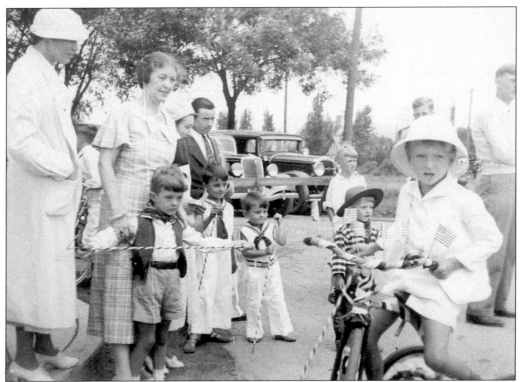

These are members of the Condon and Hemingway families at the parade in 1934. The Condons lived in the apartments in the Civic Center.

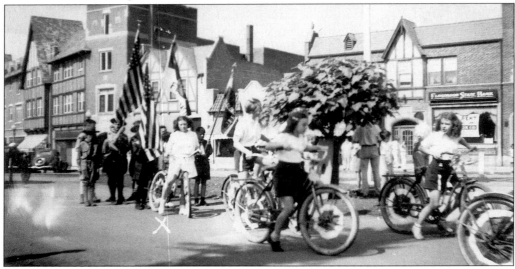

The parade is held in the morning, and during the early years, everyone then went to the school playground for afternoon games and races. As Flossmoor grew, it became difficult to have all the events in one day. The fun fair, sponsored in June by the Parent Teacher Organization, took the place of these games and races. Pictured here, on the left, is Geri Nelson Aron in the 1937 parade.

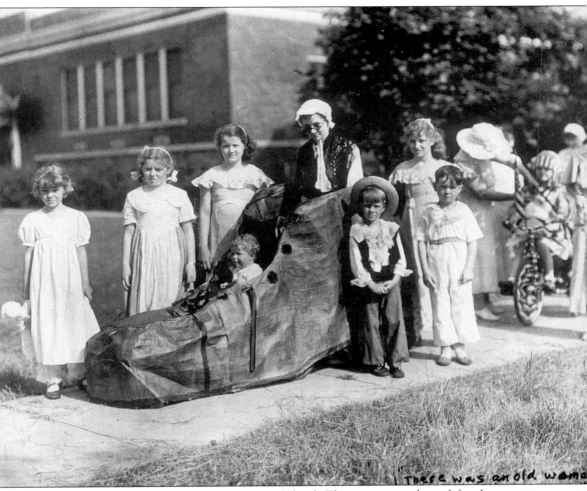

"There was an old woma

The parade used to begin at Leavitt Avenue School. This group was dressed for the nursery rhyme, "There was an old woman who lived in a shoe." Fred Vanderwalker built the shoe for his daughters in 1935. The children are Winifred Vanderwalker (in the shoe) and in the front row, Michael Jacobus and Don Hamilton. In the back row are Carol Vanderwalker, Shirley Vanderwalker, Gail Hamilton, Janet Vanderwalker, Barbara Vanderwalker, and on the far right is their mother, Laura Vanderwalker.

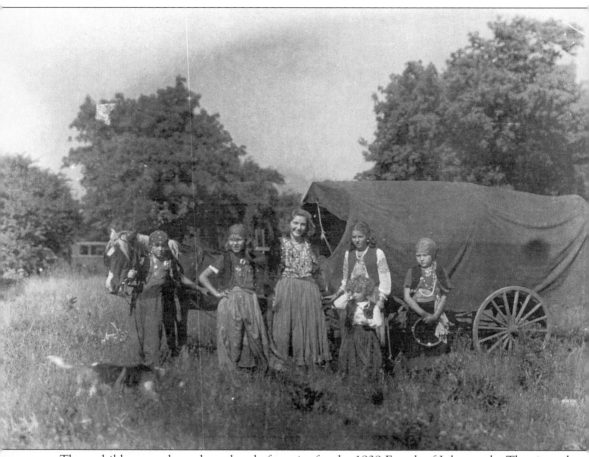

These children are dressed as a band of gypsies for the 1939 Fourth of July parade. The rig and pony belonged to the Hamilton family. The children are, from left to right, Don Hamilton, Carol Vanderwalker, Barbara Vanderwalker, Winifred Vanderwalker, Shirley Vanderwalker, and Betty Adams.

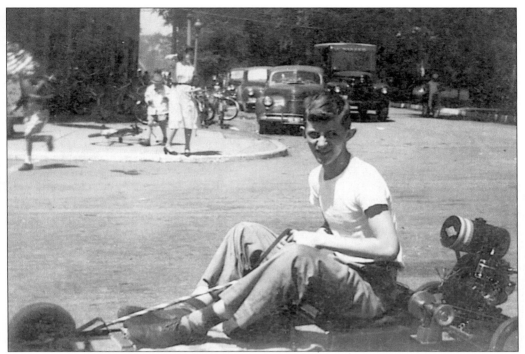

In 1943, Richard Condon was in the parade with his home built go-cart. Through the years, many of the Flossmoor children took great delight in building something on wheels to ride in the parade. Often, a neighborhood of children would work for weeks on one entry that could get quite elaborate. Since the Condons lived in the Civic Center apartments, this go-cart was probably built in the garage or courtyard of that landmark.

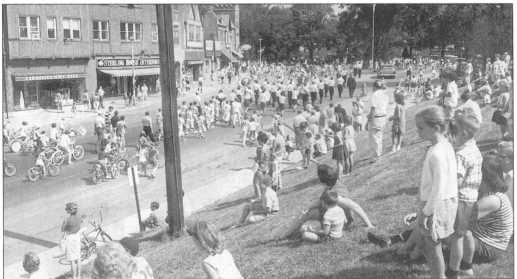

Anyone who ever went to the parade will know how typical this picture is. By this time, the Flossmoor Volunteer Fire Department had become the sponsor of the parade. It was not unusual for there to be more people in the parade than spectators.

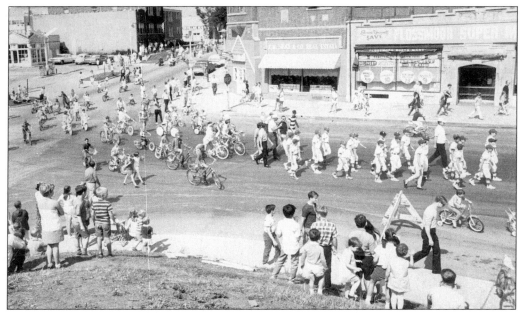

The parade shown here is heading east on Flossmoor Road and turning north on Sterling to pass the old Flossmoor Super Mart. It is just a short block to the circle where the judges are waiting to make their decisions and award the prizes.

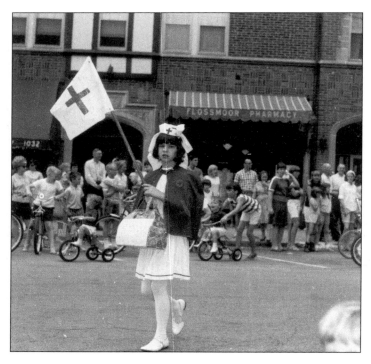

This Red Cross nurse reflects the World War II effort, felt even among the children. As soon as the awards were presented, the firemen always put on some type of demonstration of their latest equipment.

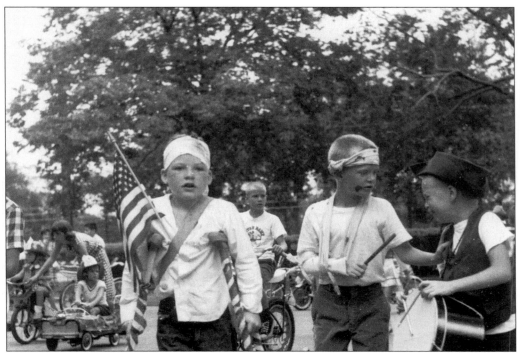

Here we have an unhappy young drummer and two of the walking wounded, again reflecting World War II feelings (c. 1944).

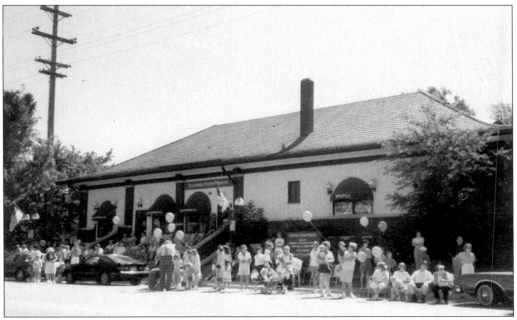

This picture shows a group of spectators (parents and grandparents) waiting for the parade in front of the train station, when it was home to small shops and boutiques. This is a prime seat, since the circle where the parade ends and the entries are judged is just across the street.

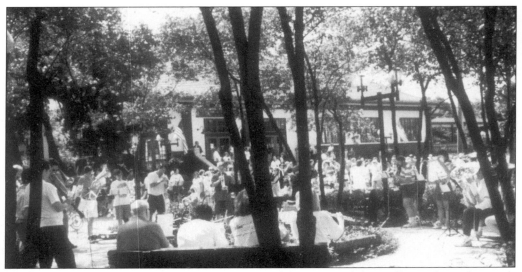

Here, a community band plays patriotic songs in the interior of the traffic circle at the north end of downtown Flossmoor. After the parade, residents chat and admire the children's efforts as they enjoy refreshments and ice cream with old friends who come back each year for the Fourth of July celebration in Flossmoor.

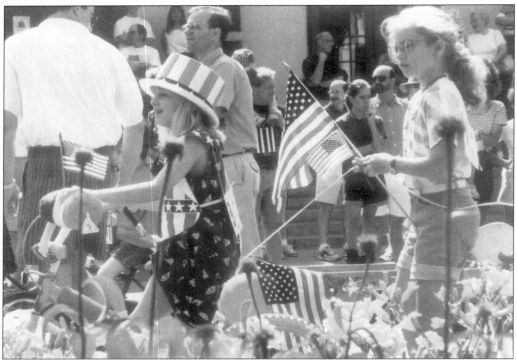

Not much has changed in the Fourth of July parade over the years. Flags wave, people wear their red, white, and blue costumes, and generations come together to enjoy our community.

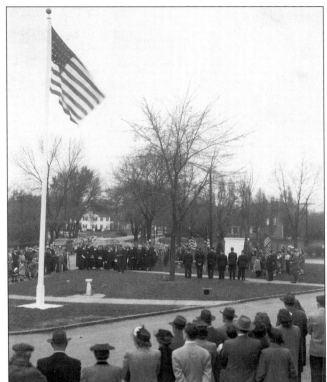

Friends and neighbors gathered to dedicate a WW II memorial on April 1, 1945. The memorial was erected by the local American Legion, and honored the men and women from Flossmoor who were serving in our armed forces. The ceremony took place in the downtown traffic circle, before the new village hall was erected on the north side of the circle in 1950.

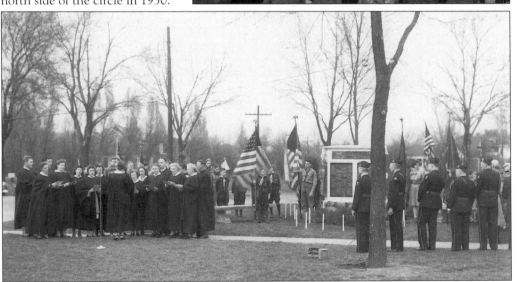

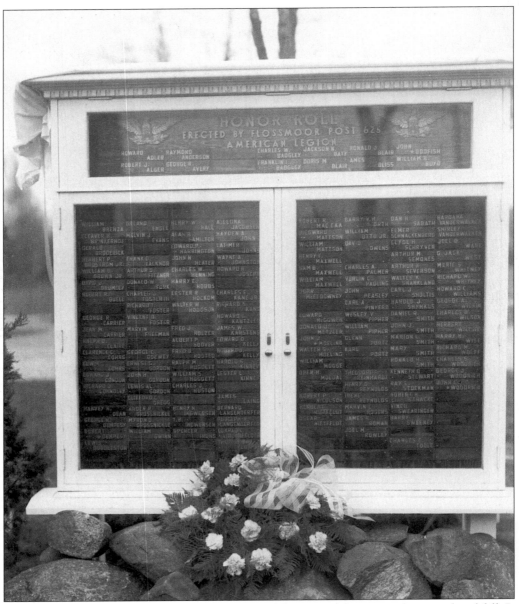

This close-up of the memorial shows the names of the men and women who served and fell. It stood in the circle for many years, but there is no record of when it was removed. This picture is particularly precious since the memorial cannot be located, and may be the only record of those members of the community who served.

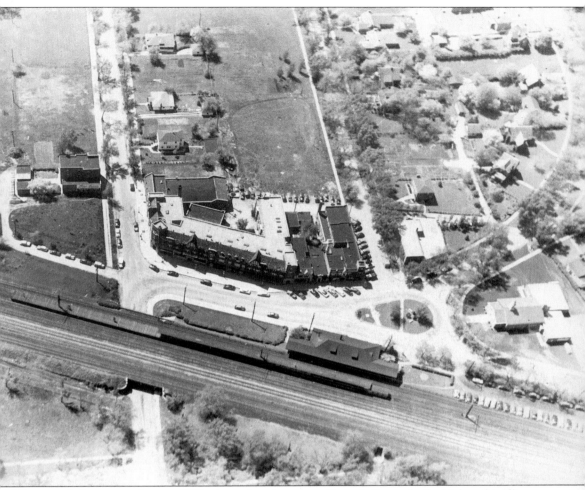

This aerial shot was taken *c.* 1951, just after the new village hall was built (right of traffic circle). While the downtown area is clearly defined by the train station and Civic Center, the surrounding neighborhoods are much less developed than today

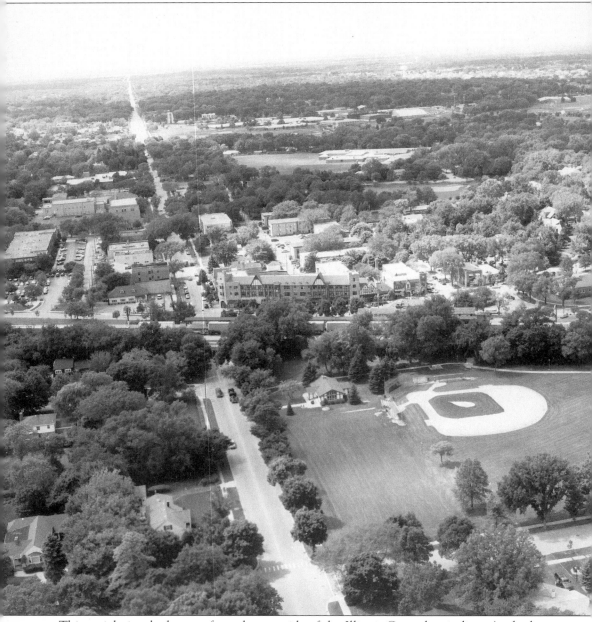

This aerial view looks west from the east side of the Illinois Central train line. At the bottom right is a baseball diamond, which becomes a skating rink in the winter. The small building in the park is used as a warming house for skaters in the winter and as a polling place at election time. The large buildings in the distance are the high school campus on the corner of Flossmoor Road and Kedzie Avenue. Just west of the train tracks is Flossmoor's crown jewel, the Civic Center building.